creative edge
PAGE DESIGN
lynn haller

NORTH LIGHT BOOKS
Cincinnati, Ohio

Creative Edge: Page Design. Copyright © 1998 by North Light Books. Manufactured in Singapore. All rights reserved. No part of this book may be reproduced in any form or by any electronic or mechanical means including information storage and retrieval systems without permission in writing from the publisher, except by a reviewer, who may quote brief passages in a review. Published by North Light Books, an imprint of F&W Publications, Inc., 1507 Dana Avenue, Cincinnati, Ohio 45207. (800) 289-0963. First edition.

Other fine North Light Books are available from your local bookstore, art supply store or direct from the publisher.

02 01 00 99 98 5 4 3 2 1

Library of Congress Cataloging-in-Publication Data

Haller, Lynn.
 Page design / Lynn Haller.
 p. cm. — (Creative edge series)
 Includes index.
 ISBN 0-89134-848-4 (alk. paper)
 1. Layout (Printing) I. Title. II. Series.
Z246.H35 1997
686.2'252—dc21 97-23616
 CIP

Edited by Lynn Haller
Production edited by Marilyn Daiker
Designed by Brian Roeth

The permissions on page 142 constitute an extension of this copyright page.

North Light Books are available for sales promotions, premiums and fund-raising use. Special editions or book excerpts can also be created to specification. For details, contact: Special Sales Manager, F&W Publications, 1507 Dana Avenue, Cincinnati, Ohio 45207.

ACKNowledgments

ACKNOWLEDGMENTS

Thanks to those behind the scenes at North Light who took the disk and the pile of art that I handed over and transformed them into a real book—especially to Marilyn Daiker, who oversaw all of the details and made sure the whole production process ran smoothly (as it always does when she's in charge), and to Brian Roeth, who designed an excellent cover and interior for the book. Thanks also to all the designers who provided work for the book, and who were so forthcoming in writing about their work.

table of coNTENTS

TABLE OF CONTENTS

CONCEPT

Sometimes it's just the idea behind the page layout that pushes it one step beyond the rest. See twenty examples where the idea drives all the other elements.

TYPE

While virtually all design calls for type, not all design uses type in such an extraordinary way. See thirty-three examples of designs that do.

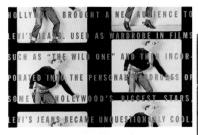

IMAGE

In this section, it's a striking image or group of images that give these thirty-six pieces the edge over their competition.

LAYOUT

The thirty-two examples in this section take all of the elements listed in the other sections—concept, type and image—and tie them together in a layout that breaks boundaries—and maybe a grid or two, too.

INTRoduction

INTRODUCTION

The end of print is a hoax.

A hoax, that is, if the quantity and quality of entries for our first Creative Edge book are to be believed. Open this book, and you'll probably agree with me that print design—and more specifically, page design—is alive and well. You hold the evidence in your hands.

This is not to say that other highly-touted *page-less* page design—such as Web page design—isn't having its impact on print: We've included examples of outstanding Web page design in this book, as well as print design that has been influenced by the Web (for examples of the latter, see pages 33, 114 and 137).

But in this book—where the *pages* featured range from magazine and book design to brochures, ads, CD booklets and posters—print is still king.

And by the way, if you're wondering where we got the term *creative edge*, looking at the designs featured in this book should answer that question. If there's one thing all the designers featured in this book have in common, it's the fact that they all have an edge over their competition when it comes to creativity.

It's my hope that the work featured in this book will push you to aspire to that same edge in your own work. And if you do? Please tell me about it—I'm already looking for fresh talent for our next Creative Edge book.

Lynn Haller

CONCEPT

TYPE

IMAGE

LAYOUT

Most designers would probably agree that all good design (and that would include all the pieces in this book) is concept driven. But in the twenty designs featured in this section, concept is front and center—the thing you notice first when you look at the piece.

In this section you'll see:

• how Cole Gerst took the title of a new CD release—*All the Nations Airports*—and ran with it thematically, even to the extent of dangling out of an airplane that was taking off to get the perfect cover photograph.

• how Smokebomb—using seventies-style design and production techniques—followed a band's directive to create a seventies-style tour poster "designed from concept to press with nothing but a strobe light to guide our path."

• how Bill Cahan used an original Harlequin romance illustrator to illustrate an annual report for one of the top software creators in the country—and made it work.

"PEEL SLOWLY AND SEE" BOX SET BOOKLET

ART DIRECTORS/DESIGNERS: Phil Yarnall and Stan Stanski,
with Spencer Drate, Jütka Salavetz and Sylvia Reed

STUDIO: Smay Vision, Inc., New York, NY

CLIENT/SERVICE: Polydor/Chronicles/record company

PHOTOGRAPHER: Various

TYPEFACES USED: Rotis Semi-Serif (body copy)

SOFTWARE: QuarkXPress, Adobe Photoshop

COLORS: Four, process

PRINT RUN: 50,000

CONCEPT: "When we started this project, we were basically
presented with a huge pile of incredibly cool stuff from
Velvet Underground guitarist Sterling Morrison's per-
sonal archive," say Phil Yarnall and Stan Stanski. "This
included virtually every poster for the band's concerts,
from which we dissected and used the elements
throughout the 94-page book as we saw fit." This treat-
ment worked because "it featured a great deal of the
original art available and really reflected the layered
musical content of the Velvet Underground's sound."

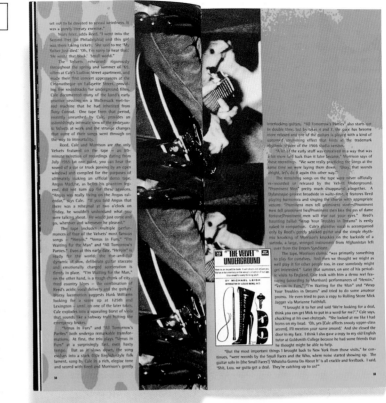

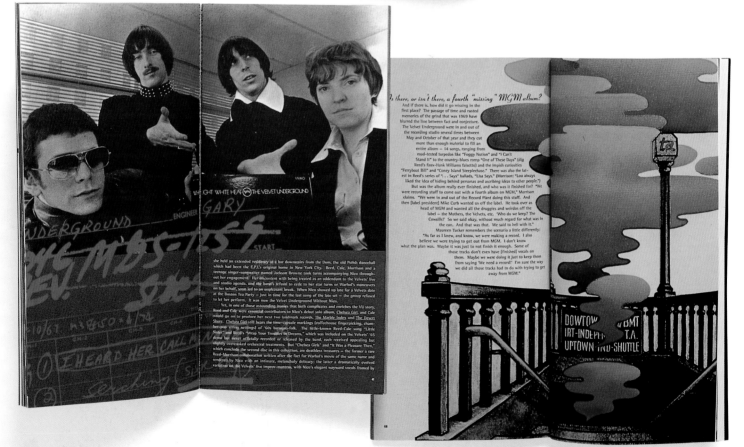

"PEEL SLOWLY AND SEE" CD COVERS

ART DIRECTORS/DESIGNERS: Phil Yarnall, Stan
Stanski

STUDIO: Smay Vision, Inc., New York, NY

CLIENT/SERVICE: Polydor/Chronicles/record
company

SOFTWARE: QuarkXPress, Adobe Photoshop

COLORS: Four, process

PRINT RUN: 50,000

CONCEPT: "Among all the groovy things we had to
work with" for this cover design for a boxed set of
Velvet Underground CDs, "we had the original
master tape boxes, which were covered with the
band's handwriting, rubber stamps, recording
notes, wads of tape, coffee stains, etc.," say Phil
Yarnall and Stan Stanski. "We picked up elements
from them for the insides as gritty collages under
the track listings." This concept was appropriate
because "it maintained the rawness of the set,
which included many outtakes, demos and early
recordings that, until this set came out, existed
only on these and other similar dusty old tapes."

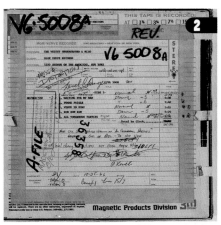

MACROMEDIA ANNUAL REPORT

ART DIRECTOR: Bill Cahan

DESIGNER: Craig Clark

STUDIO: Cahan & Associates, San Francisco, CA

CLIENT/PRODUCT: Macromedia/technology

ILLUSTRATOR: Will Davies

PHOTOGRAPHERS: Tony Stromberg, various

TYPEFACES USED: New Caledonia, Zapf Dingbats, Twentieth Century

SOFTWARE: Macromedia FreeHand, Adobe Photoshop

COLORS: Four, process

CONCEPT: "Macromedia as a company has two different personalities: one expressing a straightforward business vision, and one that is casual, fun and expressive. We decided to express Macromedia's product line through the vehicle of a quasi pulp fiction novel. We hired an original Harlequin romance novel illustrator (age 76) and created a story of a powerful woman novelist who wanted much more than to just produce a novel—she wanted to *shock* the world via the Internet using Macromedia's extensive product line." The annual report consists of two parts, with two different covers, one of which details the "shocking true story!" of "my life in the multimedia fast lane!" depicted Harlequin romance style; the other is a more straightforward annual report treatment.

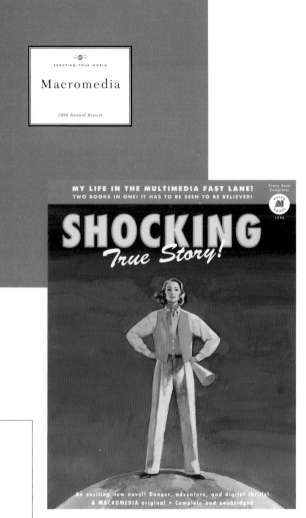

High-tech hijinks! With instant network savvy, Kate was ready to tackle the Web. The Backstage Internet Studio brought her total database connectivity and the newest, coolest visual development tools. "WWWow! Thanks to Shockwave, my story is coming alive on the Internet." Suddenly, she was a bigger hit than ever. Number one with a bullet! But that's not all. Out of the blue, Kate got an email from a student at the New Media University. He'd created a course based on her thrill-a-minute life story using Authorware Interactive Studio. Golly, a novel idea! "It was impossible to ignore your life story," he said with glee. "You're an inspiration to us all!"

· · ·

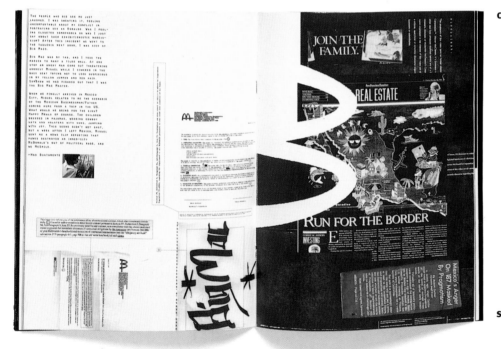

ART DIRECTOR/STUDIO/LOCATION: Joshua Berger/Plazm Media/Portland, OR

DESIGNER/STUDIO/LOCATION: John Boiler/Wieden & Kennedy/Portland, OR

CLIENT/PRODUCT: Plazm Media/magazine, digital type foundry, design group

PHOTOGRAPHER: Various video stills

TYPEFACES USED: Code Heavy, Code Steady

TYPE DESIGNER: Angus R. Shamal (Code Heavy, Code Steady)

SOFTWARE: Adobe Photoshop, QuarkXPress

COLORS: One, black

PRINT RUN: 8,000

CONCEPT: "This is the print documentation of an extended performance piece in which Nao Bustamente travels from San Francisco to Mexico City as Ronaldo McDonaldo, the Latino Ronald McDonald," says designer John Boiler. "The editorial content provided the inspiration for the piece. Bustamente posing as a well-known corporate spokesperson rampaging through the United States to Mexico reminded me of some kind of heroic bank robber on the lam. The layouts were put together like a detective's scrapbook. Microfiche negatives, clippings, clues and video stills all combine as *evidence* of the crime."

SPECIAL PRODUCTION TECHNIQUES: "Faxed myself some of the letters used in the layout so that they looked like evidence one step removed. Wrinkled, folded and photo-copied art so that it looked like it came from different places."

MEAD CONFERENCE PROMOTION

ART DIRECTOR: Lana Rigsby

DESIGNERS: Lana Rigsby, Jerod Dame

STUDIO: Rigsby Design, Houston, TX

CLIENT/PRODUCT: Mead/fine paper

ILLUSTRATOR: Erik Adigard

PHOTOGRAPHER: Terry Vine

TYPEFACES USED: Thesis: TheSans; Thesis: TheMix

TYPE DESIGNER: Luc(as) de Groot (TheSans and TheMix)

SOFTWARE: QuarkXPress, Adobe Illustrator, Adobe Photoshop

COLORS: Four, process, plus two, match

PRINT RUN: 10,000 to 75,000 (depending on piece)

CONCEPT: "This series promotes Mead's conference dealing with the changes in the annual report industry—one of the most profound of which is the move to electronic reporting," says Amy Wolpert of Rigsby Design. "Numbers are the basis of financial reporting, but corporate image is most often the driver behind annual report design. This image underscores that dual purpose by using numbers to create an image for the conference."

SPECIAL PRODUCTION TECHNIQUES: The central image was created by digitally altering information from a computer screen display of stock prices. It was printed with overlays of match metallic inks. The *Graphis* cover utilizes a split ink fountain with two match metallic inks.

Two of every three corporations doing business today will not exist in 2006.

The survivor[s] will be companies that understand design...

1996 Mead
Annual Report Conference
October 3 and 4 1996
Millennium Broadway
New York

Keynote speaker Thursday, October 3, 1996
Global Paradox
John Naisbitt, one of the leading authorities on trends, transformation and change. Author of the bestsellers *Megatrends*, *Reinventing the Corporation*, *Megatrends 2000*, *Global Paradox (the Larger the World Economy, the More Important Its Smallest Players)*, and most recently, *Megatrends Asia* examines the paradox facing business in the new millennium.

Thursday, October 3 & Friday, October 4 —Topics and sessions
Glocalization, Implementation and Corporate Vision
William D. Lutz, Professor of English, Director of English Graduate Program for Rutgers University; author of the bestseller *Doublespeak (Communicating in the Corporate Jungle)* and *The New Doublespeak (Why No One Knows What We're Saying Anymore)* talks about corporate communications and plain language.

Communicating the Social Accountability of Business
Words, Pictures & the Spirit Behind Them
Alan Parker, Manager of Investor Relations for **Ben & Jerry's Homemade, Inc.** explores the connection between commerce and communities.

The Secret Formula for Coca-Cola
Lowell Williams, partner in the international design consultancy **Pentagram**, on working with the Real Thing—**Coca-Cola**.

Considerations
Linda Wertheimer, host of National Public Radio's **All Things Considered** and editor of the bestseller *Listening to a Nation*, takes a witty and undoubtedly piquant look at the nation's business climate just weeks before the 1996 presidential election.

sex, clients & videotape
Tom Katzenmeyer, Director of Investor Relations, **The Limited** and **Kent Hunter**, Executive Creative Director, **Frankfurt Balkind Partners** talk about annual reports—and a corporate culture you can dance to.

Growing up with Progressive
Peter B. Lewis, President, Chairman and CEO of **The Progressive Corporation**, and **Joyce Nesnadny**, principal of **Nesnadny+Schwartz** discuss their 13-year collaborative relationship.

Will there be a Mead Annual Report Conference in 2006?
An open-forum discussion on the future of annual reports, moderated by **Jack Summerford**.

Conference chair: Lana Rigsby

Friday evening, October 4
40th Anniversary Mead Annual Report Show Gala Opening
at the Rainbow Room atop Rockefeller Center

The AIGA Business Conference will follow on October 5-6, also at the Millennium.

Watch for more information to come, or call **312-664-0231**
for registration information

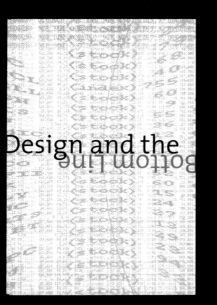

Design and the Bottom Line

ART DIRECTOR: Alexander Isley

DESIGNER: Kim Okosky

STUDIO: Alexander Isley Design, Redding, CT

CLIENT/PRODUCT: Reebok International Ltd./shoes and apparel

ILLUSTRATOR: James Steinberg

PHOTOGRAPHERS: Monica Stevenson, various

TYPEFACES USED: HTF Champion, Adobe Caslon

TYPE DESIGNER: Jonathan Hoefler (HTF Champion)

SOFTWARE: QuarkXPress, Adobe Photoshop, Adobe Illustrator

COLORS: Four, process, plus two, match

PRINT RUN: 60,000

CONCEPT: About this annual report for Reebok International, Veronica Burke says, "Our goal was to create an annual report that had the spirit and pacing of a magazine, providing interesting and appropriate content in an engaging manner."

SPECIAL PRODUCTION TECHNIQUES: The inclusion of a double gatefold, showing Reebok activities around the world.

SPECIAL COST-CUTTING TECHNIQUES: Use of some existing photographs, in-house production of some artwork, silhouetted images and use of only one illustrator.

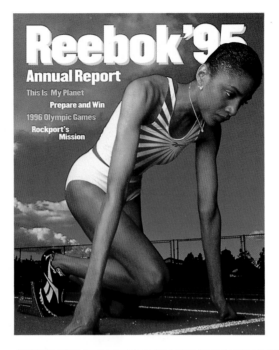

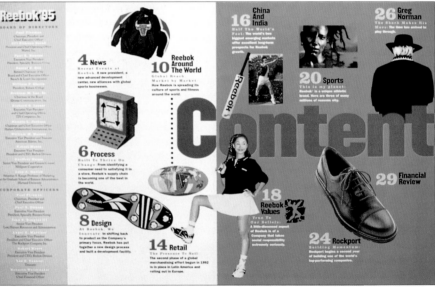

DESIGN FOR THE FUN OF IT

ART DIRECTOR/DESIGNER/ILLUSTRATOR: Neal Ashby

STUDIO: Ashby Design, Annapolis, MD

CLIENT: American Institute of Graphic Artists

TYPEFACES USED: Headliner

SOFTWARE: QuarkXPress, Adobe Illustrator, Adobe Photoshop

WRITER: Jennifer Kornegay

COLORS: Four, process (brochure); one (envelope)

PRINT RUN: 5,000

CONCEPT: "I know as a designer I throw away invites all the time, so I wanted to put something in people's hands that got them involved," says Neal Ashby of this invitation he designed for an AIGA event. "I thought the popcorn bag would be a neat trick and also, hopefully, get people interested in the theme for the program, which is *fun.*"

SPECIAL PRODUCTION TECHNIQUES: Conceiving the idea of popcorn-bag-as-envelope was the easiest part of the process of designing the envelope: According to Ashby, "The bags took a month to find, mostly because popcorn bags come preprinted. In the end, we didn't use popcorn bags at all, but rather submarine sandwich bags. After we bought the bags, it became apparent that the only way to print them was on a letterpress. The printer who agreed to do the job for the AIGA didn't have a letterpress but helped me find someone who did—two guys working out of their garage in rural Pennsylvania (they did it as a hobby)."

SPECIAL TYPE TECHNIQUES: "The invitation uses a big, thick typeface named Headliner, which has the woodblock feel I wanted for an old-time carnival look. The big red number *2* is in Headliner."

SPECIAL COST-CUTTING TECHNIQUES: "I think a few thousand plain popcorn bags cost about $80, and the printing was only $400."

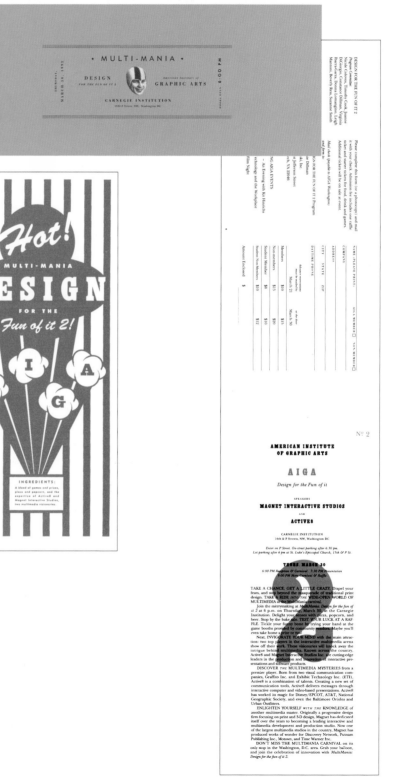

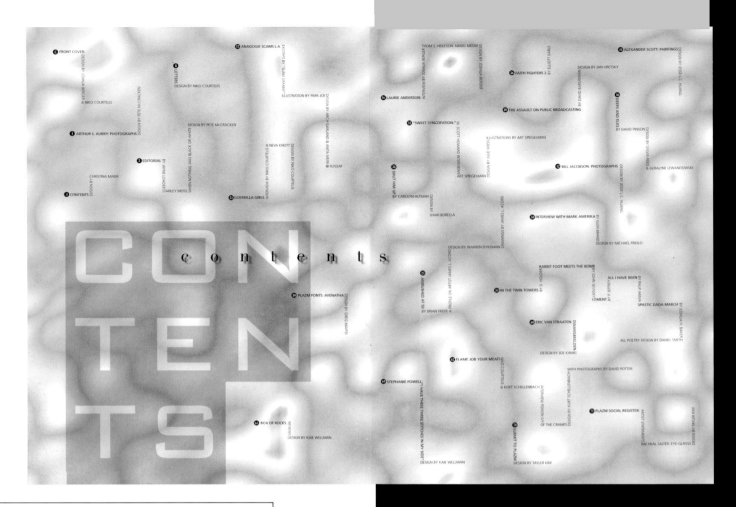

CREATIVE EDGE: PAGE DESIGN | 18

ART DIRECTOR/STUDIO/LOCATION: Joshua Berger/Plazm Media/Portland, OR

DESIGNER/STUDIO/LOCATION: Christina Maier/Neoglyphix/ Portland, OR

CLIENT/PRODUCT: Plazm Media/magazine, digital type foundry, design group

TYPEFACES USED: Bank Gothic, Bodoni, Frutiger

SOFTWARE: Adobe Photoshop, QuarkXPress, KPT Texture Explorer

COLORS: One, black

PRINT RUN: 8,000

CONCEPT: "Because *Plazm* has such a wide variety of design styles and editorial content in each issue," says designer Christina Maier, "I wanted to provide the reader with a sort of road map to its contents. The background is meant to imply a USGS topographic map. The page number, title and author information were set at right angles to one another to encourage the reader to turn the spread and, thus, change viewing orientation in order to follow the course. To combat the width of the word *contents*, I broke it into syllables to obtain a more vertical design element."

SPECIAL PRODUCTION TECHNIQUES: "I used Photoshop for the display type and KPT Texture Explorer to get the topo map image. Quark was used to lay out the smaller type and compose the elements."

DER STIFIKUS ANNUAL REPORT

ART DIRECTORS/DESIGNERS: Lucia Frey, Heinz Wild

STUDIO: Wild & Frey, Erlenbach, Switzerland

CLIENT/SERVICE: Stiftung Umwelteinsatz Schweiz/ environmental protection foundation

ILLUSTRATOR: Various

TYPEFACES USED: Dynamoe, Berling

SOFTWARE: QuarkXPress, Adobe Photoshop

COLORS: One, match

PRINT RUN: 6,000 German, 2,000 French

COST PER UNIT: 2 CHF

CONCEPT: To convey the spirit of this small, personal environmental protection foundation, Heinz Wild wanted a concept "that really enhances the respect and appreciation of nature and every little creature." To that end, he says, "Every other page of the report features an animal or a plant—not the famous ones, but the most common ones, those people normally dislike, such as flies, spiders, earthworms and weeds. We showed the plants and animals each on one page, added a lot of interesting information and really packed the report with unusual facts and figures." Wild describes the look of the piece as "undesigned, rough and childlike" and adds that "we used every blank space to add a loving little detail"; since this annual report is widely distributed to government offices, schools and potential donors, its fun, approachable look was meant to "set apart the foundation from the eco-political extreme many eco-organizations are associated with—it shouldn't be angry, annoying or too radical."

SPECIAL COST-CUTTING TECHNIQUES: The small format, inexpensive paper stock, one-color printing, use of line art and the self-mailer cover ("a cardboard normally used to stuff banana boxes," says Wild) all helped keep costs low.

THIS IS THE 3RD IN A SERIES OF TEN.
IN THIS ISSUE JOHN BIELENBERG
SEARCHES FOR THE EXISTENCE
OF UTOPIA WHEN THE
FUTURE IS REDUCED TO THE
FOUR WALLS OF A PRISON CELL.
JOHN'S SUBJECT IS A WOMAN
AND A CONVICT,
INCARCERATED FOR LIFE.
UTOPIA IS A NEW COATED LINE FROM
APPLETON PAPERS. JOHN'S ISSUE IS
PRINTED ON UTOPIA TWO, BLUE WHITE
GLOSS, 80LB. TEXT.

UTOPIA CONVICT BROCHURE

ART DIRECTOR/DESIGNER: John Bielenberg

STUDIO: Bielenberg Design, Boulder, CO

CLIENT/PRODUCT: Appleton Papers Inc./coated paper

PHOTOGRAPHERS: Ray Niemi, John Bielenberg

TYPEFACES USED: Helvetica Inserat, Futura (vellum wrapper)

SOFTWARE: QuarkXPress

COLORS: Four, process, plus two, varnish

CONCEPT: This promotional piece for a paper company "needed to feel very different from the normal paper promotion—to promote by being nonpromotional," says designer John Bielenberg. In this piece, Bielenberg played off the name of the paper—Utopia—by utilizing an e-mail quotation "to show how a female convict's utopian dream of the future had been degenerated"; to this end, the quotation, "Utopia does not exist for me anymore," is printed across the brochure's four-color images in varnish.

INSPIRATION: "My Uncle Ray's Super 8 home movies from 1962 and the Starn twins, Mike and Doug."

SPECIAL PRODUCTION TECHNIQUES: To achieve the unique visual effect of this piece, Bielenberg enlarged his Uncle Ray's original Super 8mm film to color prints, ripped the prints up and taped them back together again. The quotation that is the centerpiece of the brochure is printed over four-color process images in dry-trap pearlescent varnish.

Notorious Female Convict
via E-mail 2/94

THIS IS THE 3RD IN A SERIES OF TEN.
IN THIS ISSUE JOHN BIELENBERG
SEARCHES FOR THE EXISTENCE
OF UTOPIA WHEN THE
FUTURE IS REDUCED TO THE
FOUR WALLS OF A PRISON CELL.
JOHN'S SUBJECT IS A WOMAN
AND A CONVICT,
INCARCERATED FOR LIFE.

ART DIRECTORS/DESIGNERS: Sonia Greteman, James Strange

STUDIO: Greteman Group, Wichita, KS

CLIENT/SERVICE: Wichita Industries and Services for the Blind/ training center, workplace and service provider for the visually impaired

ILLUSTRATOR: James Strange

TYPEFACES USED: Franklin Gothic, Garamond

SOFTWARE: Macromedia FreeHand

COLORS: Two, black and match

PRINT RUN: 5,000

COST PER UNIT: $3

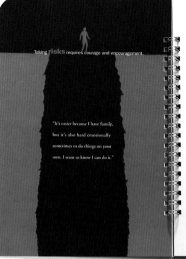

CONCEPT: "Rather than celebrate contracts acquired and quotas achieved," says designer Sonia Greteman, "this annual report [for Wichita Industries and Services for the Blind] challenges readers to *see* the world as a blind person does. To consider the isolation and problems that blindness brings. To realize the courage needed to move from dependency to interdependency. The use of real quotes from employees who are blind gives the book power and allows it to speak bluntly, boldly and honestly. Striking, emotional imagery communicates what it's like to live in an unsighted world. Pictures, print and Braille give readers insight both visually and tactilely."

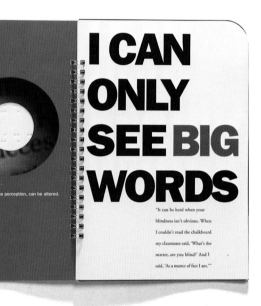

INSPIRATION: "A child's storybook. Through the use of spiral binding and heavyweight paper, the annual report is perceived as a book—a storyteller."

SPECIAL PRODUCTION TECHNIQUES: "Included the use of embossing to reinforce the importance of touch to those who cannot see."

SPECIAL COST-CUTTING TECHNIQUES: "Included designing all the embossed pages to be printed in a single press run, with only one pass. The rest of the book was kept to a simple, two-color print job, with another press sheet for the die cut."

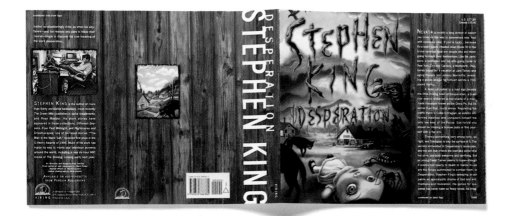

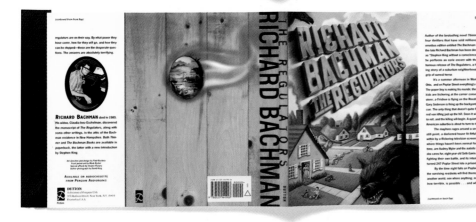

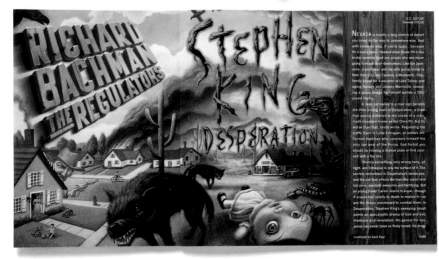

ART DIRECTOR/DESIGNER: Paul Buckley

STUDIO: Penguin USA, New York, NY

CLIENT/SERVICE: Penguin USA/book publishing

ILLUSTRATOR: Marc Ryden

TYPEFACES USED: Hand-lettering

TYPE DESIGNERS: Marc Ryden, Shasti O'Leary

SOFTWARE: QuarkXPress, Adobe Photoshop

COLORS: Four, process, and one, match

PRINT RUN: 1,000,000 each

CONCEPT: The need to convey the interrelated nature of these simultaneously published novels drove the concept for these covers: "If you put both books side by side [as shown at bottom left] you will see that together they create one large painting," says Paul Buckley. "Then, if you turn them over, the Bachman art is reflected on the King novel and vice versa in an old pulpy, knothole kind of way—further clues to the interaction between the two books."

SPECIAL TYPE TECHNIQUES: "Marc Ryden designed the letterforms and Shasti O'Leary (Photoshop superhero) took the rough type and made it dimensional, complete with glows and shadows," says Buckley.

GVO BROCHURES

ART DIRECTOR: Bill Cahan

DESIGNERS: Bob Dinetz ("Chances That There Is Life…"); Kevin Roberson ("What's Love Got To Do With It?," "Maybe Good Design Isn't Pretty")

STUDIO: Cahan and Associates, San Francisco, CA

CLIENT/SERVICE: GVO/industrial design

ILLUSTRATORS: Bob Dinetz, Gary Baseman ("Chances That There Is Life…"); Nick Dewar ("What's Love Got To Do With It?")

PHOTOGRAPHER: Various

COPYWRITERS: Stefanie Marlis ("Chances That There Is Life…," "What's Love Got To Do With It?"); Danny Altman ("Maybe Good Design Isn't Pretty")

TYPEFACES: Hand-lettering, IBM Selectric

SOFTWARE: QuarkXPress, Adobe Photoshop

CONCEPT: "Our charge from GVO (an industrial design firm) was to create a glossy, perfect bound 32-page brochure with nice pictures of their product designs to send to CEOs to get them interested in GVO," says Bill Cahan. "After extensive research on our end, we found out that GVO employs an ethnographic approach to research that focuses on how people live in the real world, doing everyday things like cleaning toilets and washing dishes. This approach runs counter to other industrial design firms that focus on creating beautiful products to create consumer interest. We decided to go beyond the brochure idea, and create a five-tiered direct marketing campaign in the size of the *Wall Street Journal*—a size and medium familiar to CEOs. Each week they would get a different brochure in a brightly colored plastic bag, with a different message on what it takes to create breakthrough products."

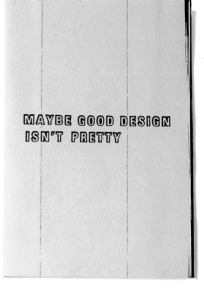

THIS BROCHURE, ENTITLED "MAYBE GOOD DESIGN ISN'T PRETTY," USES THIS TAG LINE TO BEGIN AN EXPLANATION OF THE DIFFERENCE BETWEEN THE VALUE OF BEAUTY AND OF USEFULNESS IN A PRODUCT.

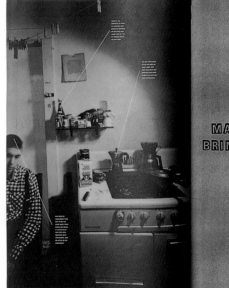

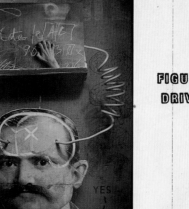

This brochure, entitled "Chances That There Is Life On Another Planet," lists a number of situations that are against the odds (having triplets, getting hit by lightning, etc.) to lead up to the low odds of a product succeeding, and to explain how, with the help of GVO, launching a product doesn't have to be a gamble.

CHANCES THAT
THERE IS LIFE ON ANOTHER PLANET:
1 IN 1,000,000,000

SLIM TO NONE

SLIM TO NONE

CHANCES THAT
YOUR NEXT PRODUCT WILL BE A WINNER:
1 IN 10,000

IF IT WAS SIMPLY A MATTER OF PLAYING THE ODDS, YOU MIGHT CONSIDER HATCHING SALMON, OR, FOR THAT MATTER, YOU MIGHT AS WELL BUY A LOTTERY TICKET. IT'S EASIER

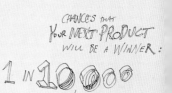

This brochure, entitled "What's Love Got To Do With It?," uses example "love stories"—products that should have been what the consumer wanted, but failed because of poor understanding on the launching company's part—to explain the value of understanding what consumers want.

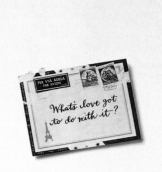

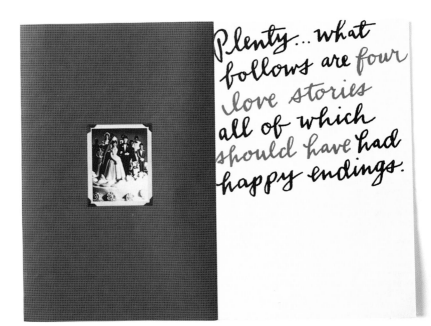

Plenty...what follows are four love stories all of which should have had happy endings.

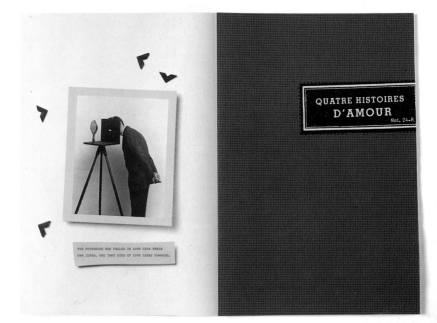

QUATRE HISTOIRES D'AMOUR Mod. 24-R

THE COMPANIES HAD FALLEN IN LOVE WITH THEIR OWN IDEAS, AND THAT KIND OF LOVE LEADS NOWHERE.

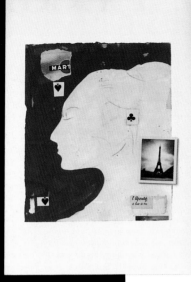

It's an old story:
a guy takes his
wife to Paris for
their anniversary,
without finding out
what she wants.
The next year he
does. She falls
in love with him
all over again.

Love Story No. 1

The company behind Bob* thought that because
you spent a lot of time at your PC, you'd
want to make a personal friend out of it. But
you wanted a simple, productive tool, not an
animated interface with a bunch of bizarre
personalities. You were treated like a child.

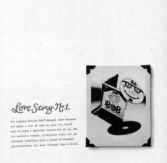

Love Story No. 2

They wanted to put the world in the palm of
your hand. Newton* was supposed to translate
your handwriting into ASCII text; the trouble
was the meaning got lost in translation.
Free to you, And just as frustrating, Newton
didn't connect to much of anything.

THE MORAL: FIND OUT WHAT YOUR CUSTOMERS
REALLY WANT, THEY'LL LOVE YOU FOR IT.

ART DIRECTORS/DESIGNERS: Lucia Frey, Heinz Wild

STUDIO: Wild & Frey, Erlenbach, Switzerland

CLIENT/SERVICE: Spital Wil/hospital

ILLUSTRATOR: Various, reworked by Lucia Frey and Heinz Wild

PHOTOGRAPHER: Client-provided x-rays

TYPEFACES USED: OCRB (headlines, graphs), Stempel Garamond (body copy, graphs and statistics)

SOFTWARE: QuarkXPress, Adobe Photoshop

COLORS: Two, match; three, match (overlay)

PRINT RUN: 2,000

COST PER UNIT: 15 CHF

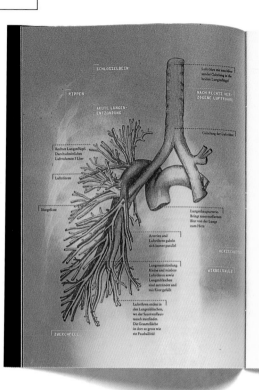

CONCEPT: Heinz Wild says of this annual report for a hospital, "We targeted two purposes: We wanted to communicate the hospital's very good performance of the previous year, and we wanted to portray the hospital and its individual departments. The 'X-Rays' concept made it possible to tell about the departments' activities and to make medical science accessible to the reader." Wild adds that "medical topics are in fact extremely interesting even to the general public, if you present the subject in an eyecatching way." While containing all the statistics an annual report needs to contain, Wild says that the annual report also functioned as an image brochure: "It brought a lot of new clients to the hospital."

SPECIAL COST-CUTTING TECH-NIQUES: Two colors were used throughout, with three colors used only on the overlays. Using x-rays instead of expensive photography, and getting a special rate from the printer, who intended to use this as a promotional piece, also kept costs down.

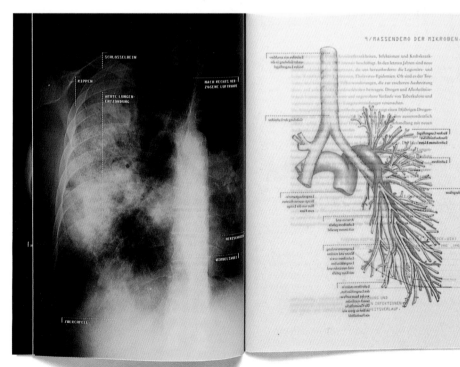

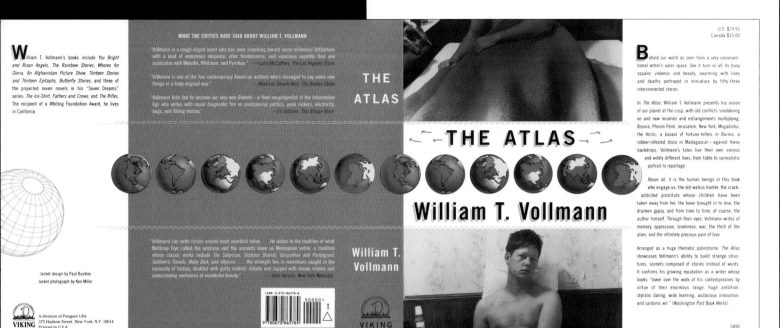

<div style="border:1px solid;">

"THE ATLAS" COVER

</div>

ART DIRECTOR/DESIGNER: Paul Buckley

STUDIO: Penguin USA, New York, NY

CLIENT/PRODUCT: Penguin USA/book publishing

PHOTOGRAPHER: Ken Miller

TYPEFACES USED: Trade Gothic

SOFTWARE: QuarkXPress, Adobe Illustrator, Adobe Photoshop

COLORS: Four, process, plus two, match

PRINT RUN: 25,000

CONCEPT: Inspired by the title of this book, Paul Buckley says, "I wanted to create something that looked like an old atlas and mix it with that great photo of Vollmann in a hotel bed with mouthwash on the nightstand." This approach effectively conveyed the book's blend of autobiography and travel journalism.

ART DIRECTORS/DESIGNERS: Carol Bobolts, Kayt deFever, Deb Schuler

STUDIO: Red Herring Design, New York, NY

CLIENT: Chronicle Books

PHOTOGRAPHER: Joe Wittkop

TYPEFACES USED: Kaufmann, Gill Sans, Aachen

SOFTWARE: QuarkXPress, Adobe Photoshop, Adobe Illustrator

COLORS: Four, process

PRINT RUN: 30,000

CONCEPT: "The book began as a few simple reminiscences, almost like a word association game, until the game evolved into a list and eventually into a book," Carol Bobolts says of *Do You Remember,* a book full of images that will resonate with anyone who grew up in the seventies. The design, which couples simple depictions of the images with playful type treatments, allows the images to speak for themselves.

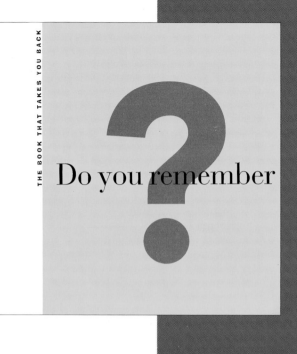

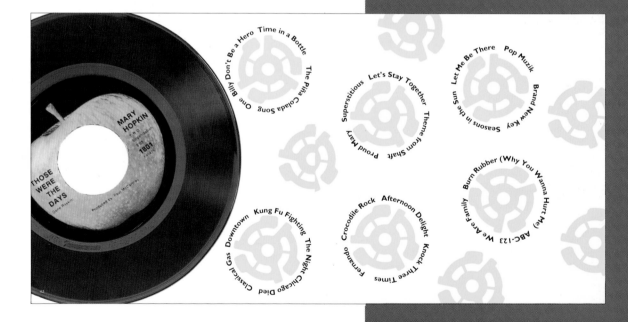

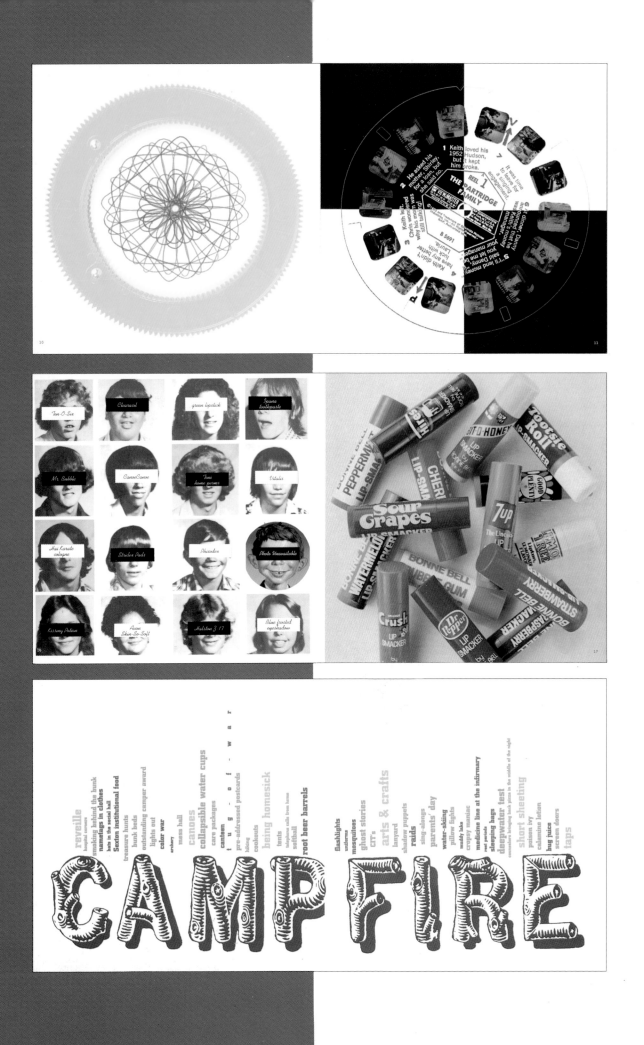

ART DIRECTOR: Brian Cohen/Elektra

DESIGNERS: Brian Kelly, Nancy Mazzei

STUDIO: Smokebomb, Brooklyn, NY

CLIENT/SERVICE: Elektra Entertainment and Sub Pop/record labels

ILLUSTRATORS: Brian Kelly, Nancy Mazzei

TYPEFACES USED: Havinhouse; logo supplied by band

TYPE DESIGNER: House Industries (Havinhouse)

SOFTWARE: Adobe Photoshop, QuarkXPress

COLORS: Five, match

PRINT RUN: 2,500

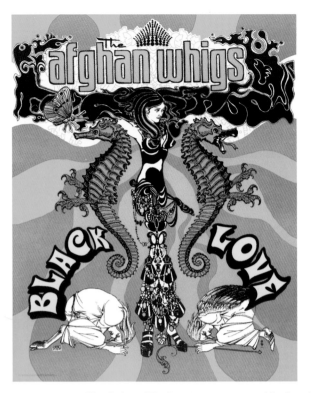

CONCEPT: "The Afghan Whigs really wanted this poster to be 'confused' with a poster from the seventies," say designers Brian Kelly and Nancy Mazzei about this tour poster. "The concept was not to upgrade the style but to create a period piece." The designers add that even copyright notices were excluded from the piece so that no dates would betray the poster's nineties origin.

INSPIRATION: "The Fillmore posters of the sixties and seventies, Day-Glo colors, demonic satanic sexy girls—all that great classic rock and roll iconography. Angels and demons bowing to the goddess of black love. This poster was designed from concept to press with nothing but a strobe light to guide our path."

SPECIAL PRODUCTION TECHNIQUES: "We felt that, in order to replicate a poster from this era correctly, we would have to utilize the same processes used back then. The layout was composed in Quark, but final mechanicals were done with stats and ruby; the offset printing was done by a local Brooklyn shop on equipment that dates back to the fifties."

SPECIAL COST-CUTTING TECHNIQUES: "Total production costs were less than $50—one board, five sheets of ruby and black pen."

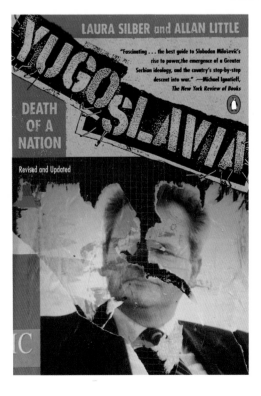

ART DIRECTOR: Paul Buckley

DESIGNER: Jesse Marinoff Reyes

STUDIO: Penguin USA, New York, NY

CLIENT/PRODUCT: Penguin USA/book publishing

PHOTOGRAPHERS: Chip Hires, Gamma Liaison

TYPEFACES USED: Futura Bold Condensed, Futura Demi Bold

SOFTWARE: QuarkXPress

COLORS: Four, process

PRINT RUN: 12,000

COST PER UNIT: $0.415

CONCEPT: Jesse Reyes says of this book cover design, "As with all book subject matter, the first elements of inspiration must be the content itself—in this case, the current events nature of the war in the former Yugoslavia. The cover had to have a relocated, tattered look, not only because of the disruptive nature of war in general, but also to indicate a culture, a people, being ripped apart. Imagewise, I imagined a kind of east European modernism beaten down and ripped to shreds (imagine the anarchic work of punk designer Jamie Reid through the context of civil war)."

SPECIAL COST-CUTTING TECHNIQUES: A full-color scan of a textured oatmeal paper stock was used as a background texture instead of the paper itself, keeping costs down. The cover photograph was obtained from a photo-news service at a reasonable rate.

ART DIRECTOR: Sonia Greteman

DESIGNERS: Craig Tomson, Sonia Greteman

STUDIO: Greteman Group, Wichita, KS

CLIENT: Wichita Area Chamber of Commerce

TYPEFACES USED: Bank Gothic, Garamond

SOFTWARE: Macromedia FreeHand

COLORS: Two, black and match

CONCEPT: This annual report for the Wichita Area Chamber of Commerce "worked for the client by projecting the Chamber as a technologically up-to-date and progressive force providing leadership and savvy to the business community," says designer Sonia Greteman.

INSPIRATION: "The Chamber's wish to position itself as forward-thinking, progressive and attuned to the times" was the inspiration for this treatment, says Greteman. "This piece accomplishes this by linking the Chamber with the ever-rising use of electronic media for information exchange, while still communicating the Chamber's message through the medium of print. The Web *page* and banner with buttons serve as important image references."

SPECIAL PRODUCTION TECHNIQUES: The die-cutting used "draws the reader through the piece in a manner similar to common computer navigation. It acts much like links through a home page and icons captured through screen shots."

SPECIAL COST-CUTTING TECHNIQUES: "The use of straight-line dies and printing on color paper add to the visual impact—but not the printing costs—of a third color."

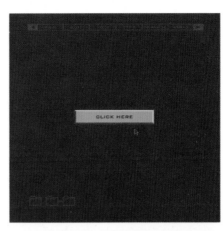

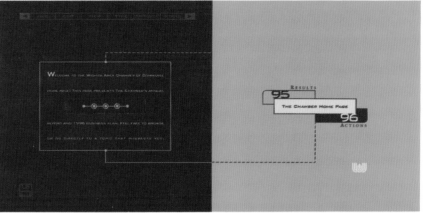

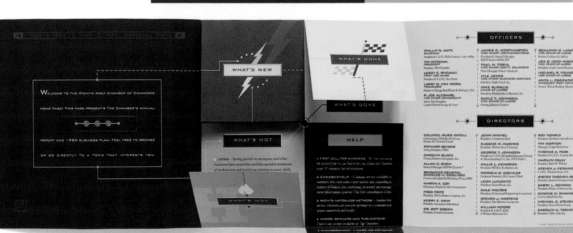

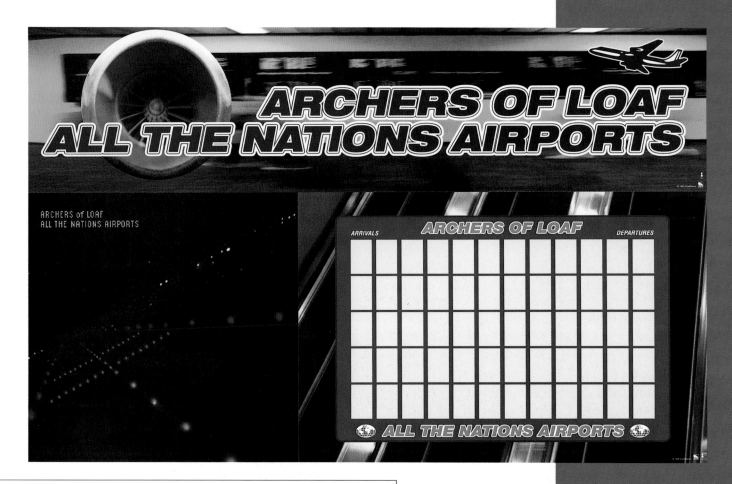

"ALL THE NATIONS AIRPORTS" PACKAGING AND PROMOTION

ART DIRECTOR/DESIGNER/ILLUSTRATOR/

PHOTOGRAPHER: Cole Gerst

STUDIO: Alias Records, Burbank, CA

CLIENT/PRODUCT: Alias Records/music

TYPEFACES USED: Emperor 8(CD, LP, poster, sticker), Departure (back tray card), Helvetica New Black

TYPE DESIGNER: Cole Gerst (Departure), Zuzana Licko (Emperor 8)

SOFTWARE: Macromedia FreeHand, Fontographer, Adobe Photoshop, QuarkXPress

COLORS: Four, process

PRINT RUN: 30,000 (CD); 5,000 each (cassette and LP)

CONCEPT: "The concept not only worked with the title of the album but with the whole feel of the album," says designer Cole Gerst. "The stark cover really gives a feeling of what the music is like inside. When it came time to do items related to the album, I tried to make them in a totally different way by focusing on a more airline-oriented design with the imitation emergency exit card single and the AOL sticker with the world and the circling airplane."

INSPIRATION: "The title of the album, along with the song of the same name. I actually met the band in an airport before they were flying to Europe to discuss the album artwork. Obviously, it couldn't have been a more perfect setting. We walked through the airport as we talked about different ideas we could use. I wrote down notes and sketched, as well as taking pictures the whole time."

SPECIAL TYPE TECHNIQUES: Gerst created the font Departure by bringing Emperor Eight into FreeHand, converting to paths, manually breaking it into squares and rearranging it, and then importing this into Fontographer, where size and kerning were finalized.

SPECIAL COST-CUTTING TECHNIQUES: All design, illustration and photography was done in house by Gerst ("I actually hung my body out of a plane with someone holding my legs for about 15 take-offs and landings to get the cover shot," he says.) To maximize usage, Gerst made a three-in-one perforated poster that can be displayed separately or together.

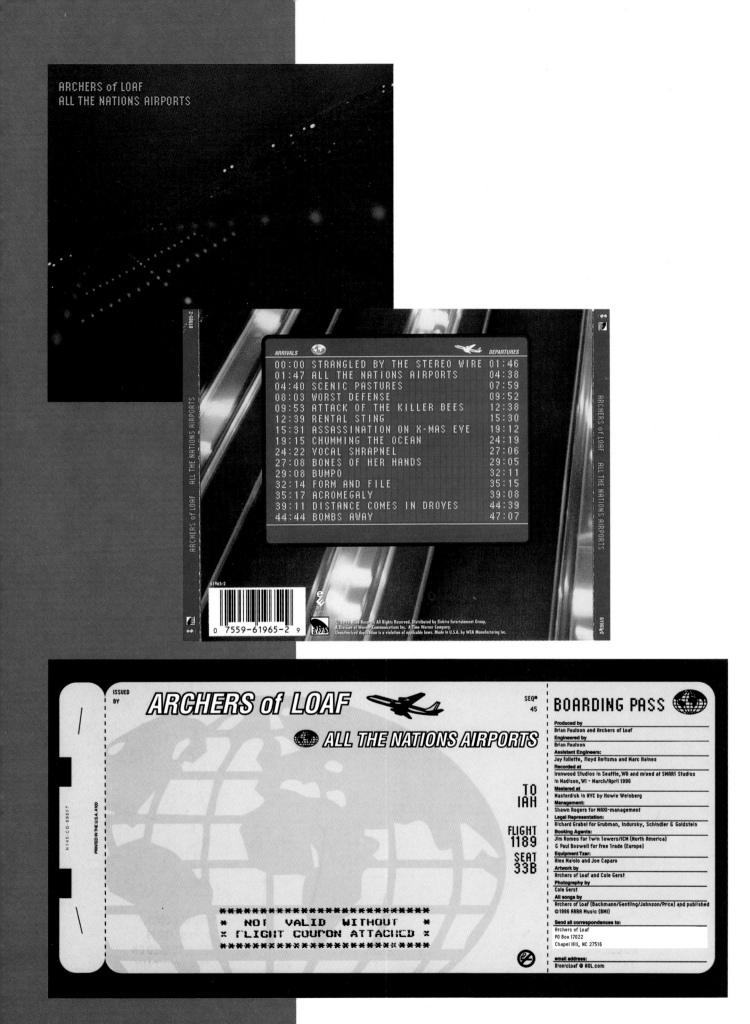

ARCHERS of LOAF
ALL THE NATIONS AIRPORTS

ARRIVALS		DEPARTURES
00:00	STRANGLED BY THE STEREO WIRE	01:46
01:47	ALL THE NATIONS AIRPORTS	04:38
04:40	SCENIC PASTURES	07:59
08:03	WORST DEFENSE	09:52
09:53	ATTACK OF THE KILLER BEES	12:38
12:39	RENTAL STING	15:30
15:31	ASSASSINATION ON X-MAS EVE	19:12
19:15	CHUMMING THE OCEAN	24:19
24:22	VOCAL SHRAPNEL	27:06
27:08	BONES OF HER HANDS	29:05
29:08	BUMPO	32:11
32:14	FORM AND FILE	35:15
35:17	ACROMEGALY	39:08
39:11	DISTANCE COMES IN DROVES	44:39
44:44	BOMBS AWAY	47:07

ARCHERS of LOAF ALL THE NATIONS AIRPORTS

61965-2

0 7559-61965-2 9

℗ 1996 Alias Records. All Rights Reserved. Distributed by Elektra Entertainment Group,
A Division of Warner Communications Inc. A Time Warner Company.
Unauthorized duplication is a violation of applicable laws. Made in U.S.A. by WEA Manufacturing Inc.

ARCHERS of LOAF

ALL THE NATIONS AIRPORTS

ISSUED BY

SEQ# 45

BOARDING PASS

TO
IAH

FLIGHT
1189

SEAT
33B

Produced by
Brian Paulson and Archers of Loaf
Engineered by
Brian Paulson
Assistant Engineers:
Jay Follette, Floyd Reitsma and Marc Haines
Recorded at
Ironwood Studios in Seattle, WA and mixed at SMART Studios
in Madison, WI - March/April 1996
Mastered at
Masterdisk in NYC by Howie Weinberg
Management:
Shawn Rogers for MAXI-management
Legal Representation:
Richard Grabel for Grubman, Indursky, Schindler & Goldstein
Booking Agents:
Jim Romeo for Twin Towers/ICM (North America)
& Paul Boswell for Free Trade (Europe)
Equipment Tzar:
Alex Maiolo and Joe Caparo
Artwork by
Archers of Loaf and Cole Gerst
Photography by
Cole Gerst
All songs by
Archers of Loaf (Bachmann/Gentling/Johnson/Price) and published
© 1996 ARRA Music (BMI)

Send all correspondences to:
Archers of Loaf
PO Box 17022
Chapel Hill, NC 27516

email address:
Bionicloaf @ AOL.com

```
*********************
*  NOT  VALID  WITHOUT  *
*  FLIGHT COUPON ATTACHED  *
*********************
```

PRINTED IN THE U.S.A. A100
N145-CG-89607

CONCEPT

TYPE

IMAGE

LAYOUT

It's a rare design that doesn't use type in some form. But the designers in this section employ type in ways that go far beyond their computer's default type—and even beyond fonts that already exist—to include manipulated versions of standard typefaces, and even typefaces that were specially created for the project at hand.

In this section you'll see:

• how Margo Chase was inspired by the "bold and ugly" typefaces of the 1970s to create a custom font entitled Fatboy.

• how the designers at Kerosene Halo gave Bodoni an unexpected twist by simply flipping a few of the characters.

• how Paul Nicholson, inspired by a conversation with a band's lead singer about the singer's love for spirals , created a spiralled logotype for a CD package.

DESIGNER: Margo Chase

STUDIO: Margo Chase Design, Los Angeles, CA

CLIENT: Semiotext(e) Architecture magazine

TYPEFACES USED: Bradley, custom type

TYPE DESIGNER: Margo Chase (Bradley; "atom" logo)

SOFTWARE: Adobe Illustrator

COLORS: One, black

CONCEPT: A custom logotype serves as the centerpiece for this architecture magazine's interview with filmmaker Atom Egoyan.

ART DIRECTOR/STUDIO/LOCATION:
Joshua Berger/Plazm
Media/Portland, OR

DESIGNER/STUDIO/LOCATION: Pamela
Racs/Johnson &
Wolverton/Portland, OR

CLIENT/PRODUCT: Plazm Media/maga-
zine, digital type foundry, design
group

ILLUSTRATOR: Pamela Racs

TYPEFACES USED: Clarendon, News
Gothic, Times

SOFTWARE: Adobe Photoshop,
QuarkXPress

COLORS: Two, black and match

PRINT RUN: 8,000

CONCEPT: "The inspiration for the
piece was to draw a parallel between
the environmental needs of a plant
to ensure healthy growth and those
of a child—equating a plant's need
for light with a child's need for
knowledge," says designer Pamela
Racs. "The depicted problem
divides photosynthesis by corporate
propaganda, causing the viewer to
question what corporate involve-
ment in the classroom means for a
child's growth and development."

SPECIAL PRODUCTION TECHNIQUES:
"The type was hand drawn, scanned
and manipulated in Photoshop.
The collage was done in Photoshop
using layers—working on the cyan
and black plates only—and then
placing it into Quark and out-
putting only those plates."

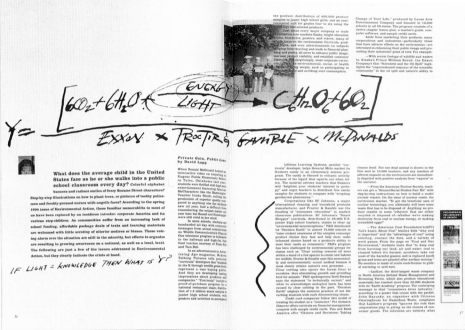

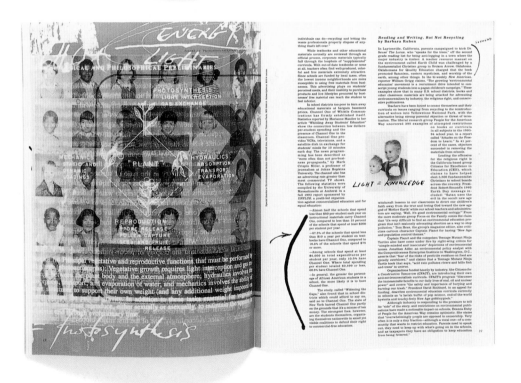

ART DIRECTOR: Paul Wharton

DESIGNER: Tom Riddle

STUDIO: Little & Company, Minneapolis, MN

CLIENT: Fraser Papers Inc.

ILLUSTRATOR: P. Scott Makela

PHOTOGRAPHERS: Geoff Kern, Hillary Bullock

TYPEFACES USED: DIN Mittleschrift

SOFTWARE: QuarkXPress, Adobe Photoshop, Pixar Typestry

COLORS: Four, process, plus one, match, plus varnish

PRINT RUN: 30,000

COST PER UNIT: $0.75

CONCEPT: "The object of change itself—what change means and how it's being experienced today" is the concept behind this brochure for Cross Pointe Passport paper, says Little & Company's Amy Dillahunt. "We also used the theme of change to subtly introduce the soon-to-happen product change of 'Passport.' P. Scott Makela's illustrations were commissioned to illustrate who, what, where, when and why technology is changing in the design industry." This concept worked for the client, says Dillahunt, because "it got designers' attention to watch for a product line change, while the allusions to technology, electronic design and future thinking reinforced the fact that Fraser Papers understands designers' interests and needs."

SPECIAL PRODUCTION TECHNIQUES: Four-color lithography, match-color duotones, fluorescent inks, double hits of color, metallic and black duotones and fluorescent four-color process were all used in the piece.

SPECIAL TYPE TECHNIQUES: P. Scott Makela used Pixar Typestry to create three-dimensional metallic words.

The times they are A CHANGIN'

PASSPORT FROM CROSS POINTE

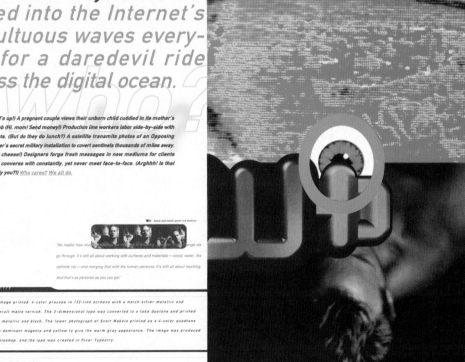

Millions and Millions of Mesmerized Eyeballs are pulled into the Internet's tumultuous waves everyday for a daredevil ride across the digital ocean.

(Surf's up!) A pregnant couple views their unborn child cuddled in its mother's womb (Hi, mom! Send money!) Production line workers labor side-by-side with robots. (But do they do lunch?) A satellite transmits photos of an Opposing Power's secret military installation to covert sentinels thousands of miles away. (Say cheese!) Designers forge fresh messages in new mediums for clients they converse with constantly, yet never meet face-to-face. (Arghhh! Is that really you?!) Who cares? We all do.

2

"No matter how much technology changes the nature of the change we go through, it's still all about working with surfaces and materials—wood, water, the cathode ray—and merging that with the human persona. It's still all about touching. And that's as personal as you can get."

PRODUCTION NOTES

This image printed 4-color process in 133-line screens with a match silver metallic and an overall matte varnish. The 3-dimensional type was converted to a fake duotone and printed silver metallic and black. The lower photograph of Scott Makela printed as a 4-color quadtone with a dominant magenta and yellow to give the warm gray appearance. The image was produced in Photoshop, and the type was created in Pixar Typestry.

Because it's there. Humans are curious animals. It is our nature to explore, probe, question all, push the envelope as far as it will go—then take one more step just to see what happens. (Uh-oh.) Columbus sailed unchartered waters to discover a New World for his Queen. Designers surf the turbulent channels of Cyberspace just to see what they can see. _For the medium isn't just the message, the message is also the medium._

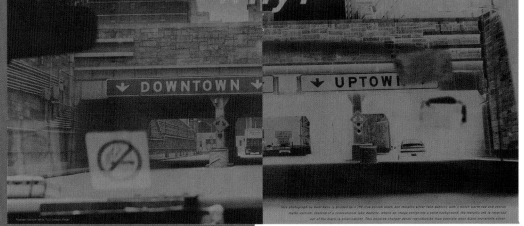

Technological advances have hit warp-speed in changing how we work, play and communicate.

where?

(E-mail's in, snail mail's out.) Orwell's Big Brother might not have been watching by 1984, but he's sure to be there in the year 2000. So who cares? Every man, woman and child with a computer on their desk (nearly all of us) will not only be watching Big Brother back, but will be chatting, spamming and lurking across **Spanning the Orb of Humanity** Cyberspace to Big Brother, Big Sister and one another on **this global link-up of humankind.**

8

'We can all take... those who say it's going so fast you can't reach it. It doesn't even take that much bravery to jump on.'

PRODUCTION NOTES

This image printed 4-color process in 133-line screens with a match silver metallic and an overall matte varnish. The upper fabric texture printed 4-color process with a fluorescent bump red on the right side of the type only. The 3-dimensional type was converted to a fake duotone and printed silver metallic and black. The image was produced in Photoshop, and the type was created in Pixar Typestry.

ART DIRECTOR/DESIGNER: Tom DeMay, Jr.

CLIENT: *Internet Underground* magazine

ILLUSTRATOR: Rich Borge/Gravity Workshop

TYPEFACES USED: Franklin Gothic, Garamond (heads); Sabon (body)

SOFTWARE: QuarkXPress, Adobe Photoshop

COLORS: Four, process

CONCEPT: "The concept of a 'tempest' served as the jumping-off point for the final layout," says Tom DeMay, Jr., of this design for an *Internet Underground* feature. "Literally, the word *tempest* in the feature represents a sophisticated technology used to spy on computer users, and the illustration clearly alludes to this. But we used the metaphor of disorder to create a more dynamic and less dry, less scientific final piece."

SPECIAL PRODUCTION TECHNIQUES: "Hand drawing letterforms and the application of a large amount of Scotch brand adhesive tape."

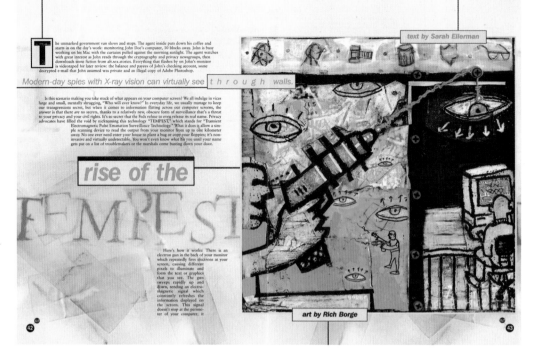

text by Sarah Ellerman

The unmarked government van slows and stops. The agent inside puts down his coffee and starts in on the day's work: monitoring John Doe's computer, 10 blocks away. John is busy working on his Mac with the curtains pulled against the morning sunlight. The agent watches with great interest as John reads through the cryptography and privacy newsgroups, then downloads some fiction from alt.sex.stories. Everything that flashes by on John's monitor is videotaped for later review: the balance and payees of John's checking account, some decrypted e-mail that John assumed was private and an illegal copy of Adobe Photoshop.

Modern-day spies with X-ray vision can virtually see *t h r o u g h* walls.

Is this scenario making you take stock of what appears on your computer screen? We all indulge in vices large and small, mentally shrugging, "Who will ever know?" In everyday life, we usually manage to keep our transgressions secret, but when it comes to information flitting across our computer screens, the answer is that there *are* no secrets, thanks to a relatively new, obscure form of surveillance that's a threat to your privacy and your civil rights. It's so secret that the Feds refuse to even release its real name. Privacy advocates have filled the void by nicknaming this technology "TEMPEST," which stands for "Transient Electromagnetic Pulse Emanation Surveillance Technology." What it does is allow a simple scanning device to read the output from your monitor from up to one kilometer away. No one ever need enter your house to plant a bug or copy your floppies; it's non-invasive and virtually undetectable. You won't even know what hit you until your name gets put on a list of troublemakers or the marshals come busting down your door.

rise of the
TEMPEST

Here's how it works: There is an electron gun in the back of your monitor which repeatedly fires electrons at your screen, causing different pixels to illuminate and form the text or graphics that you see. The gun sweeps rapidly up and down, sending an electromagnetic signal which constantly refreshes the information displayed on the screen. This signal doesn't stop at the perimeter of your computer; it

art by Rich Borge

42

43

continues expanding outwards, seeping through the ether much like a radio wave. Exposed cables act as inadvertent antennas, transmitting the contents of your screen across your neighborhood. Information even travels back along modem lines and power cords, back into the walls and out into the world. These signals can be easily reconstructed. What's more, a spy can differentiate between many different units operating in the same room. The signals don't conflict or jam each other as one might suspect. Even identical units send out distinct signals because of slight differences in the manufacturing or various components. You may not think it, but your PC is hardly a self-contained unit storing information privy to you alone. In fact, you're better off thinking of it as a small-scale broadcast station operating out of your house.

"So what if someone can see a screen?" Consider the test conducted by security professionals for the Technical Assistance Group at http://www.thecodex.com who actually jury-rigged their own Tempest scanning device and took it for a test drive in downtown Manhattan this spring. As described in an essay by CEO Frank Jones, their "DataScan" device (four years in the making) enabled them to "view CRT screens at ATM machines, banks, the local state lottery machine in a neighborhood candy store, a doctor's office, the local high school, the fire department, the local police department doing a DMV license plate check, a branch office of a securities trader making a stock trade and the local gas station (owner) tallying up his day's receipts...The U.S. Customs building (in NYC) leaks information as well as the Federal Reserve. Wall Street itself was a wealth of information for anyone interested. The World Trade Center was fertile. It afforded open parking areas nearby with millions of glass windows to snoop. We headed east toward the *New York Post* newspaper offices and read the latest news off their monitors (which was

printed the next day). We headed north toward City Hall and NYPD Police Headquarters. Guess what? They're not Tempest-certified either...Neither is the United Nations, any of the midtown banks, Con Edison (the power company), New York Telephone on 42nd Street or Trump Tower!"

Although this kind of eavesdropping has been featured in the media, most people are unaware of the ease with which spies can virtually look over their shoulder. Most react with incredulity swelling into anger and fear when the technology is demonstrated to them. However, specialists agree that the average person should not be unduly concerned with being spied on. "No, by and large it's not [used to crack down on the common criminal]," says Winn Schwartau, author of *Information Warfare* and *Security Insider Report*. "You've got to look at the expense that goes into one of these things, the eavesdropping vans and equipment. It's not cheap stuff to do at the very highest levels. As a number of prosecutors have told me, 'I wish so many people wouldn't be so paranoid. They don't know we don't have the time or the budget to waste on them.' I wouldn't worry for the individual reader; I'd worry for the corporation that has something of value."

Mike, an electronic surveillance specialist (who requested that we not print his last name) and proprietor of the Chicago-area Discreet Electronics and Security, Inc. at http://www.w2.com/docs2/z/spyshop.html, also warns the public to keep things in perspective. "Let's say you are invaded, and there's an outrage at the

invasion. It may be that your federal rights were violated...but so what?" he says. "One variable in how to assess countermeasures and detection devices is to figure out how much damage could happen to you as a result of your privacy being invaded." What could someone find out from your screen that would be of enough value or interest for them to go to the trouble and expense of getting a crack at your intellectual property? Pure curiosity? Unlikely. A nasty divorce or child custody case? The pursuit of a suspected hacker? A suspicion that you stole company secrets? Maybe.

"If, on the other hand, you're involved in something that's rather political, if you're suing an insurance company for a $500,000 worker's compensation claim, boy, there's a *lot* involved here," Mike says. "And they're going to do whatever they have to, believe it or not, to get their information."

GOOD NEWS, BAD NEWS

Paranoid or protective U.S. citizens and companies *can* purchase snoop-proof "Tempest-certified" computers for their own use. However, the high cost of such a secure system may be prohibitive to consumers, says Jules Rutstein, program manager for Secure Systems at Wang Federal, Inc. Even after paying through the nose, information on how the computer was modified to meet the undisclosed emissions standards is top-secret information, and ZONE can only be measured as relative to Tempest. It is probably safe to say that ZONE products would be acceptable for the average consumer's privacy needs, which is good news for those concerned enough with security to purchase a new computer. The bad news is that you don't have the highest level of security.

Information about exactly how the process works is

than Tempest-certified units, but Rutstein wouldn't provide *IU* with definitive figures. "We try to price our ZONE products at what we consider commercial prices. [I'm] ambivalent because it's so difficult to pin down prices on PC products today...We've been selling it from the position that you can purchase a ZONE product for virtually the same price as a normal system. It's not costing you any more." *IU* pressed to find the exact difference between the products, but emission levels are top-secret information, and ZONE can only be measured as relative to Tempest. It is probably safe to say that ZONE products would be acceptable for the average consumer's privacy needs, which is good news for those concerned enough with security to purchase a new computer. The bad news is that you don't have the highest level of security.

Information about exactly how the process works is

veiled. Seminars on building Tempest-certified equipment are only available to persons with certain security clearances, and rumor has it that people attempting to talk about Tempest are often silenced with the excuse that they're creating a security threat. Rutstein says, "Tempest is a munitions-controlled item, which means that the export of the product is controlled...Currently the only [foreign entities] we sell to are NATO governments." These prohibitions protect the U.S. from acts of terrorism, but the secrecy surrounding Tempest specifications creates a dilemma for citizens. The government's reticence about standards prevents us from properly shielding the normal computers we already own. We can guess what kind of emissions they're giving off and try to suppress them, but without cold hard data, we can never really be *sure*. Most people don't even know of the existence of the technology, much less the exact shielding specifications. "It is not possible for the average person to go to a database and find out what is Tempest-certified and what is not. I believe that perhaps that's the way the government wants it," says Jones of the

Technical Assistance Group.

Jones feels that citizens should be able to test emanations on their own. He points out that "there are several ways of blocking [unintended transmissions], but how effective are they? The people who manufacture [shielding] always say, 'it's great, it's effective,' but you don't really know. But now there is a way to test it. We built a room and we used [woven shielding] with the DataScan device and it did block [emissions], but it didn't block them to their specs. We had to use close to twice what they *thought* was secure to actually make the room secure." Mike of Discreet Electronics and Security, Inc. also comes out in favor of defensive countermeasures, saying, "Used in the application of creating awareness, to show how vulnerable, let's say, a bank could be, it actually serves a very high and valuable purpose. The idea here is to create an awareness, because most people don't know, and what's frightening is that they don't *know* that they don't know."

YEAH, BUT IS IT LEGAL?

Jones says it's somewhat unclear whether citizens can lawfully monitor electromagnetic emanations. Depending on how one interprets the 1986 Electronic Communications and Privacy Act, it seems it could be legal. According to Jones, the 1986 measure covers, in-depth, that "it is illegal to own, possess or use any device whose primary purpose is the surreptitious interception of *oral or data communications.*" How does this apply to Tempest scanning devices? Well, that depends on how you define the word "data."

Tempest works by picking up computer emanations that happen to seep into the ether, remember? Those electrons were not created to transfer information to another party; rather, they were created for putting images on a computer screen, many theorize. "The emanations are not communications, it's not 'data' by the definition of the word," Jones says. "They are spurious emissions that are nothing but

44

45

ART DIRECTORS/DESIGNERS: Karen L. Greenberg,
D. Mark Kingsley

STUDIO: Greenberg Kingsley, New York, NY

CLIENT: Xenophile Records

TYPEFACES USED: Helvetica, Urdu calligraphy

CALLIGRAPHERS: Khalil Ahmed, Shafi Naqi Jamie

PHOTOGRAPHER: Josh Pulman

SOFTWARE: Adobe Illustrator, Adobe Photoshop,
QuarkXPress

COLORS: Four, process

CONCEPT: "The fact that the booklet unfolds into an oversized piece gives this package a certain splashiness," says Karen L. Greenberg. Besides being attention-getting, there is a conceptual reason for this approach, according to Greenberg: "The music unfolds and unfolds, as does the booklet."

INSPIRATION: "Islamic geometric patterns mixed with contemporary techno-music packaging."

SPECIAL PRODUCTION TECHNIQUES: "Final composition of the patterns was done in Photoshop. To achieve the halo effect, the back cover photo was manipulated by inverting the yellow plate."

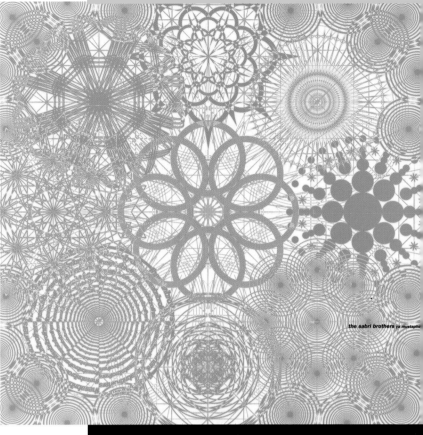

the sabri brothers ya mustapha

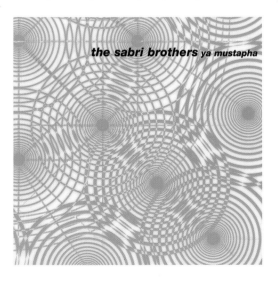

the sabri brothers ya mustapha

DRUM CLUB "LIVE IN ICELAND" CD

ART DIRECTOR/DESIGNER: Paul Nicholson

STUDIO: Prototype 21, London, England

CLIENT/SERVICE: Sabres of Paradise/record label

PHOTOGRAPHER: Sally Harding

TYPEFACES USED: Bank Gothic Light, Drum Club

TYPE DESIGNER: Prototype 21 (Drum Club)

SOFTWARE: CorelDRAW

COLORS: Four, process

CONCEPT: "All photos featured in the artwork were taken by Sally Harding, who joined the band in their tour of Iceland," says Paul Nicholson. "Through experimentation with color and layout, a cold purity and starkness was achieved to reflect the qualities of the photographs."

INSPIRATION: "The spiralled text featured on the front cover is an explosive abstraction of the Drum Club logo (also designed at Prototype 21) and stemmed from a conversation with Charlie Hall, of the Drum Club, on his love of spirals."

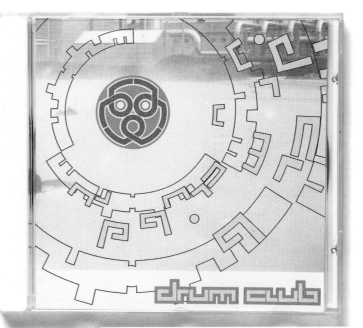

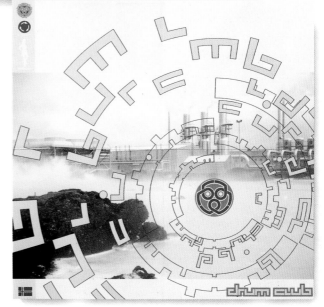

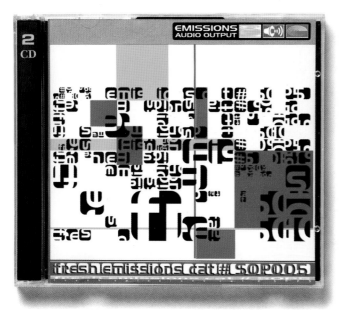

EMISSIONS AUDIO OUTPUT "FRESH EMISSIONS" CD

ART DIRECTOR/DESIGNER: Paul Nicholson

STUDIO: Prototype 21, London, England

CLIENT/SERVICE: Emissions Audio Output/record label

TYPEFACES USED: Handel Gothic Normal and Bold

SOFTWARE: CorelDRAW

COLORS: Four, match

CONCEPT: "This was an open brief and a chance to experiment," says Paul Nicholson of this CD design; he describes his solution as "the collision between Mondrian's 'Broadway Boogie Woogie,' the chopping up of Handel Gothic, the experimenting with layout and the representation of the theme 'Audio Output'"—the name of the record label for which this design was done.

ART DIRECTOR: Michael G. Rey

DESIGNER: Greg Lindy

STUDIO: REY International, Los Angeles, CA

CLIENT/SERVICE: REY International/graphic design

PHOTOGRAPHER: Michael G. Rey

TYPEFACES USED: Gill Sans, Geometric 706

TYPE DESIGNER: Eric Gill (Gill Sans)

SOFTWARE: QuarkXPress

COLORS: Four, process, plus two, match

PRINT RUN: 1,000

CONCEPT: The purpose of this oversized self-promotional brochure was to "inform others of our design services. One side was meant to show past work and information about the studio; the other side was meant to be visually interesting and to serve as a poster," says Greg Lindy. This worked for the studio because "we needed to show we can organize and present a message clearly, but on the other hand, that we are diverse and can create a piece that is self-expressive."

SPECIAL PRODUCTION TECHNIQUES: The large-image side has the words "Every problem is unique" knocked out of varnish; the informative side has the words "Every solution is unique" printed in spot varnish.

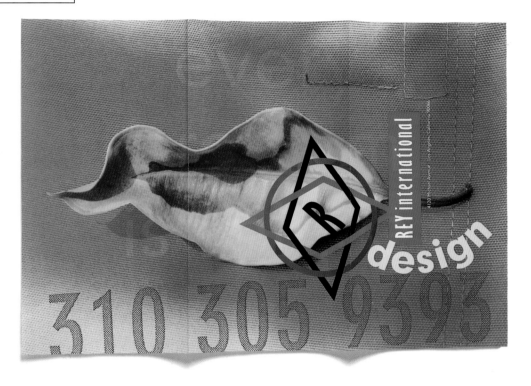

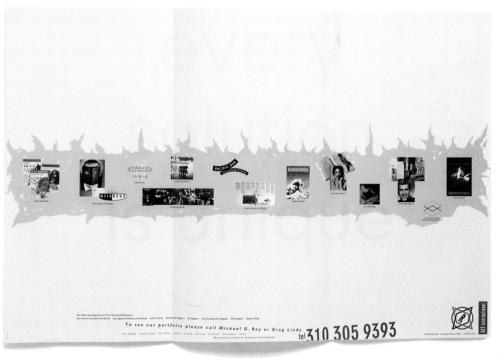

ART DIRECTOR/DESIGNER: Lori Siebert

STUDIO: Siebert Design Associates, Cincinnati, OH

CLIENT/SERVICE: Contemporary Arts Center/museum and educational outreach program

ILLUSTRATORS: Juliette Borda, Lori Siebert, Lisa Ballard, Joe Lewis III, Raven Brown

TYPEFACES USED: Hand-lettering

HAND-LETTERER: Lori Siebert

COLORS: Four, process

PRINT RUN: 5,000

CONCEPT: This brochure for the Vital Visions program, an educational outreach program sponsored by the Contemporary Arts Center for children enrolled in several of Cincinnati's inner-city elementary schools, is given as a keepsake to the children after the visiting artists' presentation. The piece features text written by the visiting artists; the illustrations (some, though not all, of which were done by the visiting artists) bring the text to life visually. To make the piece something the children can interact with, questions are scattered throughout the booklet for them to answer, and the booklet ends with blank pages and an invitation for the children to make their own mark there.

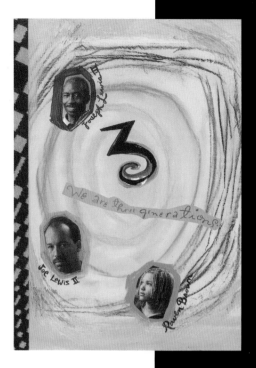

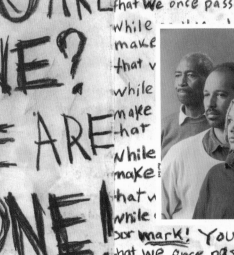

My grandmother was a Pentecostal Minister. Every summer she'd preach at different churches around the country. She lived in Atlantic City. I felt mature buying my ticket, hopping Penn Central to spend vacations with her. There was always a hot lemonade bath waiting. Gas light, parcel and plaster, stained glass and the Bible were the uncomplicated materials of her simple but devout life.

She revered the life and often said, "After your father, I consider you a miracle." The winter beach was her pulpit. And it was there, in the New Jersey sand, she'd outline the routes her private Greyhounds took. Unencumbered by modern ornament...her finger wrote the exotic places down with a humoristic precision de Memphis, Little Rock, Corpus Christi, Flint, St. Louis and our coming adventures...wind erased.

We were welcomed at each destination by the resident Elder. Psalms, jubilation, and thunderous "Amens" controlled the supernatural matters that brought us together. People came from every root to see my grandma "duke" with the Devil.

By summer's end, the Terry jitterbug stride she'd roll up to every pulpit was gone. Each sermon she delivered seemed to relate some piece of her four-score crookedness. Like clear pipe and plait pipe in Galilee, South Carolina, she glistened....wore too much lavender. That day started before "In The Garden's" last chorus.

"Over this bit of our Lord's miracle-our tired red domination shall eat us up. Mary Dop's realize how finite our planet..."

On uptressured curls she'd rip small tufts of hair from her head. The Scripture, "Numbers 18:7." "This shall be thine of most holy things, reserved from the fire..."

A baby waiting to be baptised was laced with tiny ribbons of Grandma's blood.

Down the road I found a phone to call John's Barber Shop where Dad played cards and drank beer on Sundays.

"Hello. Hello. It's Joey. Is my father—"

"Yes, sir."

"Dad? Dad Dad, you got to get me ou—"

171 **NUMBERS 18:29**

Offerings for Support of the Priests

8 And the LORD spoke to Aaron: "Here, I Myself have also given you charge of My heave offerings, all the holy gifts of the children of Israel; I have given them as a portion to you...

9 "This shall be yours of the most holy things reserved from the fire: every offering of theirs, every grain offering and every sin offering and every trespass offering which they render to Me, shall be most holy for you and your sons.

10 "In a most holy place you shall eat it; every male shall eat it. It shall be holy to you.

11 "This also is yours: the heave offering of their gift, with all the wave offerings of the children of Israel; I have given them to you, and your sons and your daughters with you, as an ordinance forever. Everyone who is clean in your house may eat it.

12 "All the best of the oil, all the best of the new wine and the grain, their firstfruits which they offer to the LORD, I have given them to you.

13 "Whatever first ripe fruit is in their land, which they bring to the LORD, shall be yours. Everyone who is clean in your house may eat it.

14 "Every devoted thing in Israel shall be yours.

15 "Everything that first opens the womb of all flesh, which they bring to the LORD, whether man or beast, shall be yours; nevertheless the firstborn of man you shall surely redeem, and the firstborn of unclean animals you shall redeem.

16 "And those redeemed of the devoted things you shall redeem when one month old, according to your valuation, for five shekels of silver, according to the shekel of the sanctuary, which is twenty gerahs.

17 "But the firstborn of a cow, the firstborn of a sheep, or the firstborn of a goat you shall not redeem; they are holy. You shall sprinkle their blood on the altar, and burn their fat as an offering made by fire for a sweet aroma to the LORD.

Tithes for Support of the Levites

21 "Behold, I have given the children of Levi all the tithes in Israel as an inheritance in return for the work which they perform, the work of the tabernacle of meeting...

Words and Music

Joseph S. Lewis III

STATES of LOSS

"After That"

After I graduate High School I would like to go to Europe for six months and live on a kibbutz in Israel for the rest of the year. Then, I would like to come back to the U.S. and go to school at Berkeley to study journalism, creative writing, history, english, photography, and film-making. After graduating from college I would like to join the peace corps and travel with them to Asia, South America, and Australia. After that I want to write a book, maybe do some journalism/photo, then I would love to write, produce, direct and act in a film. Then I would like to become a professor of history and english. I want to help CHANGE this world into a place where we are all equal and free. I want to live on the land, experience the earth. Then, I would like to move to Israel.

Graduate High School

Go to Europe for Six Months.

Live on a Kibbutz in Israel.

Go to Berkeley.

Join the Peace Corps.

Write a Book.

Write, produce, direct, act... A film.

Become a Professor.

What is your life-map? Why don't you write or draw it on the blank pages in the back of thi—

ART DIRECTOR/DESIGNER: Jonathan Hoefler

STUDIO: The Hoefler Type Foundry, New York, NY

CLIENT: Julie Holcomb Printers

TYPEFACES USED: HTF Gestalt

TYPE DESIGNER: Jonathan Hoefler (HTF Gestalt)

SOFTWARE: Fontographer, Adobe Illustrator

COLORS: Three, match

PRINT RUN: 750

COST PER UNIT: $3

CONCEPT: "The inspiration for this typeface was a tenet of Gestalt psychology, which proposes the idea that nothing is fully comprehensible out of context," says Jonathan Hoefler. "Similarly, one theory of legibility suggests that words are identified not by the order of their letters, but by their overall shape. Thus Gestalt is an experimental typeface in which most of the alphabet is ambiguous, and indeed indecipherable out of context." This typeface is the centerpiece of this letterpress-printed poster.

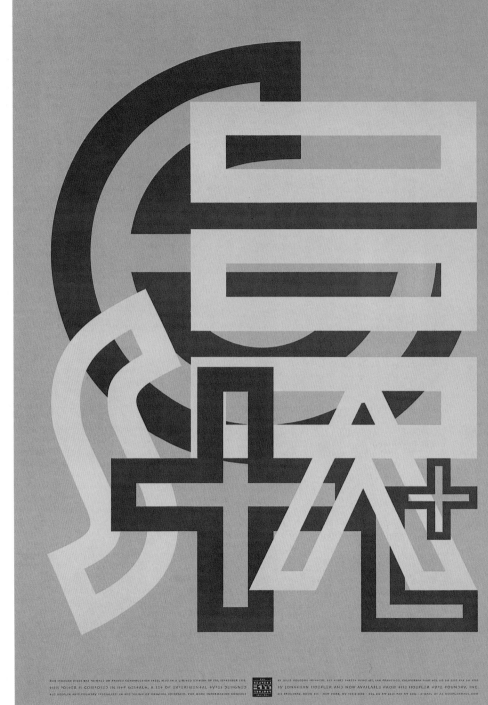

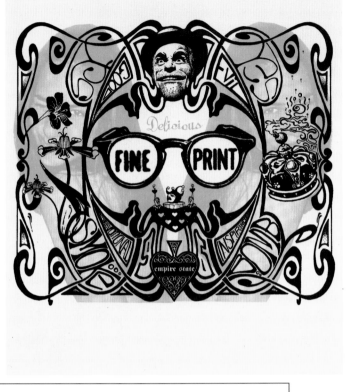

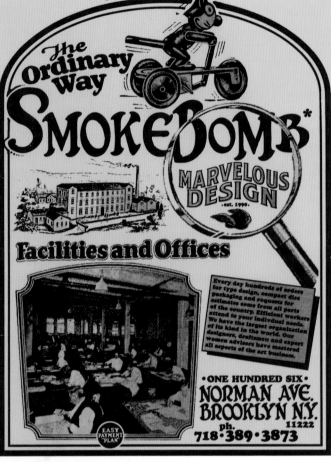

FINE PRINT POSTER/SELF-PROMOTION CARDS

DESIGNERS/ILLUSTRATORS: Nancy Mazzei, Brian Kelly

STUDIO: Smokebomb, Brooklyn, NY

CLIENT/SERVICE: Smokebomb/graphic design

TYPEFACES USED: Original or hand-drawn typefaces

TYPE DESIGNER: Smokebomb

COLORS: Two, match

PRINT RUN: 300

CONCEPT: Designer Brian Kelly says of this self-promotion, "Every element of this print is inspiring for one reason or another. This is a very personal print we both worked on during the winter months of 1995 and 1996, incorporating elements of our lives into a visual biography of Nancy and myself." Kelly says this self-promotion piece worked for the client because "there was no client—every element was exactly as I wanted it.

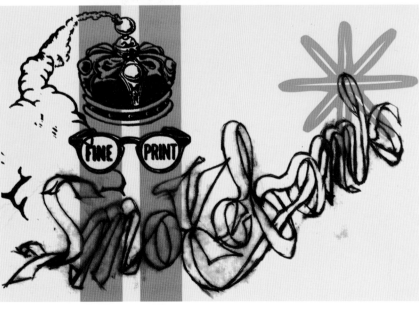

They were printed by us and mailed out as a gift. I sometimes see them in offices of people I don't even know. I enjoy it the most when I see one in the mail room or loading dock of some swanky New York building."

SPECIAL PRODUCTION TECHNIQUES: "I get comments on the printing of our self-promotion— everyone always thinks they're silkscreened. I use the same printer for every job—a local Brooklyn shop that has no computers whatsoever, it's old school all the way."

SPECIAL COST-CUTTING TECHNIQUES: "Ink: $2; board: $1.75; overlay: $0.50."

ART DIRECTORS/DESIGNERS: Thomas Wolfe, Greg Sylvester

STUDIO: Kerosene Halo, Chicago, IL

CLIENT: Tooth & Nail Records

PHOTOGRAPHERS: Thomas Wolfe (stills), Norman Jean Roy (band photography)

TYPEFACES USED: Officina, Bauer Bodoni (modified)

SOFTWARE: Adobe Illustrator, Adobe Photoshop, QuarkXPress, Fontographer

COLORS: Four, process

PRINT RUN: 10,000-15,000

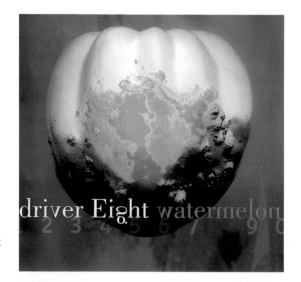

CONCEPT: "Our client came to us with one requirement for this project, that it needed to be bright," says Thomas Wolfe. "We felt the art should connect with the album title, *Watermelon*, visually, but somehow be a little unexpected. What we hoped to do was to illustrate the word *watermelon* by breaking it into two parts, *water* and *melon*. While looking for different props, we came across a squash that had some growths on it that reminded us of the continents on a globe. After scanning it into our system, we were able to change its hue to give the impression that it was floating in water, which then gave us both a representation of *water* and of *melon* and a visual which alludes to a still world perpetually hanging in space."

SPECIAL TYPE TECHNIQUES: The modified version of Bodoni was created by flipping some of the characters in Fontographer.

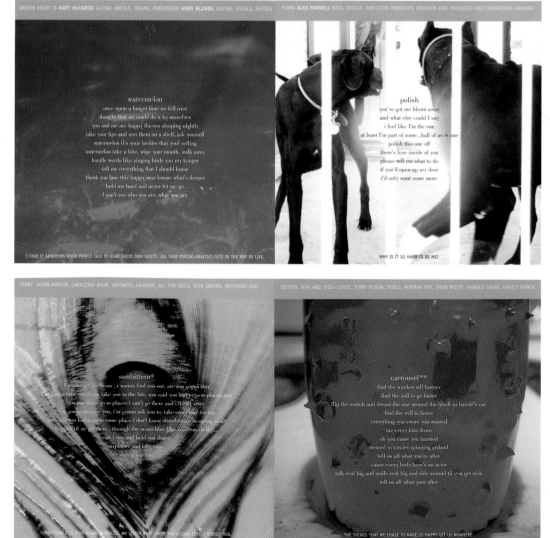

CONFETTI MAGAZINE SPREAD

ART DIRECTOR/COMPANY: Jennifer Goland/*Confetti Magazine*

DESIGNER: Lori Siebert

STUDIO: Siebert Design Associates, Cincinnati, OH

CLIENT: *Confetti Magazine*

ILLUSTRATOR: Tobin Sprout

PHOTOGRAPHER: Bray Ficken

TYPEFACES USED: Alphabet soup letters

COLORS: Four, process

CONCEPT: *Confetti Magazine* gave six well-known designers the same assignment: Take an image, a headline and a brief quotation on the subject of type and have some typographic fun with it, within the confines of a single spread of *Confetti Magazine*. Lori Siebert was one of the designers who took the challenge; Siebert used Tobin Sprout's illustration of a person in a pot as a jumping-off point for her own thoughts on condensation—thoughts appropriately illustrated through the medium of actual alphabet soup letters.

SPECIAL TYPE TECHNIQUES: "Other than standing noodles on their sides with toothpicks, no," says Lori Maechling of Siebert Design Associates.

"STOMPING DOWN HARD"—ANTHRAX EDITORIAL SPREAD

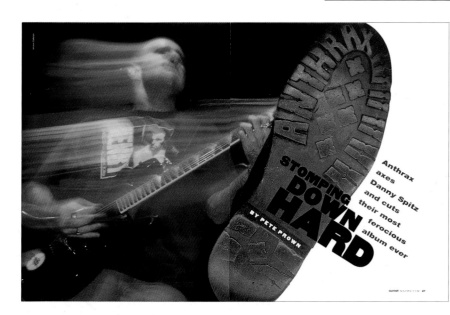

ART DIRECTOR/DESIGNER: Phil Yarnall, Stan Stanski

STUDIO: Smay Vision, Inc., New York, NY

CLIENT: *Guitar Magazine*

PHOTOGRAPHER: Kristen Callahan

TYPEFACES USED: Smokler, Helvetica

SOFTWARE: QuarkXPress, Adobe Photoshop

COLORS: Four, process

PRINT RUN: 100,000

CONCEPT: For this article for *Guitar Magazine* about the heavy metal group Anthrax, Phil Yarnall and Stan Stanski "tried to create a feeling of being a bit too close to the stage."

INSPIRATION: A new scanner—"we just bought a new scanner and started scanning everything in sight, including a boot."

SPECIAL TYPE TECHNIQUES: The "Anthrax" type was created in Photoshop by placing a boot on the scanner and cloning the treads to form the characters.

ART DIRECTOR: Clifford Stoltze

DESIGNERS: Clifford Stoltze, Dina Radeka

STUDIO: Stoltze Design, Boston, MA

CLIENT: Fidelity Investments

PHOTOGRAPHER: Various

TYPEFACES USED: Reactor, Rotis

TYPE DESIGNER: Tobias Frere-Jones (Reactor)

SOFTWARE: QuarkXPress, Adobe Photoshop

COLORS: Three, match, plus varnish

PRINT RUN: 10,000

CONCEPT: For this employee newsletter for Fidelity Investments, Stoltze Design tried to appeal to the 25- to 35-year-old employees at Fidelity with an up-to-date color scheme, type treatment and photographic treatment.

INSPIRATION: "The title of the article and Tobias Frere-Jones," says Clifford Stoltze.

SPECIAL TYPE TECHNIQUES: "The only manipulation was creating a second *B* out of two *P*'s [in Reactor] so they wouldn't be identical."

SPECIAL COST-CUTTING TECHNIQUES: "Cheap paper and begging."

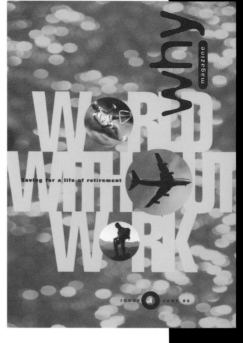

Retirement: the road to tomorrow began yesterday

by Peter Costa

If you are a typical reader of this magazine, chances are you are a financial representative, younger than 37, and have been at Fidelity for slightly more than a year. And although you may spend a significant part of your day explaining retirement investment vehicles to customers, you have yet to plan for your own life in a workless world. Like your counterparts outside Fidelity, you may view retirement as a state of an grace that other people enter, someone else, someone "old." Not you, not yet. More than 10,000 tomorrows stand between you and your gold watch. You live and work in the pressured present and have difficulty imagining a time when you will sit in a rocking chair on some front porch with a blanket wrapped around your legs.

Well, your vision of retirement, although common, does not coincide with reality. For one thing, today's retiree very likely may be someone 55 years old who is physically very fit, uses off-road vehicles to explore close lagoons, takes jet to "avis takes some jet to check out the nightlife.

Retirement is no longer just a walk in the sunset

"I think there's a shift in mindset. When people think about retirement, they envision this nice old couple walking down the beach hand-in-hand in front of a beautiful sunset. In reality, the picture is quite different. When we help people plan retirement, we are really talking about is better positioning them to make the life choices they want, when they want. So, whether that's a second career, whether they choose to get out of the work force for a while and then open up a bed and breakfast, or are actually lucky enough to really retire, Fidelity is trying to make their goals become reality," said Kathy Hopkins, Executive Vice President of Marketing.

Even among traditional, older retirees, retirement is hardly sedentary. Recent studies of people aged 65 to 75 show that retirees take 7.6 trips per year and travel more than 100 miles from their homes on each one; 16 percent play golf regularly; 11 percent enjoy working in their gardens; and 10 percent travel extensively. Boy longer and spend more on their vacations than younger people with growing children and time-demanding careers.

Joining this older group are hundreds of thousands of younger retirees in their 50s, many of whom either jumped or were pushed into early retirement by corporate downsizings. Others took advantage of so-called "window" incentives – having medical benefits paid by the company until age 65 when Medicare kicks in, having the company credit the employee with an additional five years of service, and having the company make up the difference until the early retiree is eligible for Social Security.

More than three-quarters of employees enter retirement before they are 65

Early retirement figures are startling. According to a 1994 survey of 144 private sector employees by Charles D. Spencer & Associates, Chicago, 75 percent of employees who retired did so before age 65 and only 12 percent retired after age 65. A total of 11 percent retire at age 65 and 2 percent retire because of disabilities at any age. Census Bureau statistics show a major demographic shift. In 1970, there were 70 million children under the age of 18 and 50 million adults over age 50. By the year 2010, the over-50 generation will total 97 million while there will be only 63 million children under age 18. The most rapid increase will occur between the years 2000 and 2030 when baby boomers turn age 65.

And we are not only people retiring at younger ages but they are living longer in their retirement. Studies show that in 1940 the probability that someone age 65 would live to 90 was only 7 percent; by 1980 the odds were 24 percent. The average person age 50 can now expect to thrive for 29 more years of life. Confirming this trend is that the fastest-growing segment of the population is the oldest of our old: those who are 85 or older.

Retirement today has few of the stigmas of yesteryear. People in their 40s and 50s say they look forward to retiring and pursuing activities and lifestyles free from the constraints of a regularized workday. And more and more people know they have to save to be able to do so. Per capita income is highest when people are in their 50s and 60s. It is estimated that people planning to retire have more than $1 trillion in investable assets. A recent report by the New York research firm FIND/SVP reveals that approximately 16 percent of households with a householder 55 to 74 years old have net worths of $250,000 or more, and more than 27 per cent of householders with a householder 55 to 74 have net worths of between $100,000 and $249,999. According to the Census Bureau, home equity accounts for more than 40 percent of the net worth of mature households.

'Retirement customers tend to be long-term investors who invest and hold their money at Fidelity. They also tend to be much more equity-oriented. One of the things that we have done very successfully, through representative conversations with customers, and through our marketing efforts, is really hammering home the message that long-term money should be invested in equities," Hopkins said.

People retire early for many reasons: to pursue leisure activities and enter volunteer work; to live a less stressful life; or to deal with health issues. Some retire just because it feels good not to feel bad; work in a stressful environment – eventually – can make almost anyone feel bad. "They have been working for 30 to 40 years, commuting, toiling away, and are happy not to be doing something else," said Seymour LaRock, Executive Editor of *Employee Benefit Plan Review*, published by Charles D. Spencer.

But the so-called social safety net that used to be there for older Americans lies perilously close to the ground. Social Security and Medicare benefits face a gloomy future.

The hope of financial independence

The astronomical costs of maintaining Social Security at today's standards would sticker-shock a sheik. Today, Social Security accounts for 41 percent of the income of people aged 65 and older, followed by income from assets (21 percent), public and private pensions (19 percent), earnings (17 percent), and all other sources (approximately 3 percent). More than 90 percent of the labor force is covered by Social Security with partial benefits available at age 62 and full benefits at age 65. In 1995, 46 million people age 62 and older were receiving Social Security benefits. It takes only 4.5 years for retirees to receive back all of their Social Security contributions. The maximum monthly retirement payment to someone retiring at age 65 in 1996 is $1,248. The system transfers approximately $350 billion a year to recipients.

To keep Social Security costs down, the eligibility age for receiving full Social Security retirement benefits is scheduled to increase from 65 to 67 by the year 2088. But even with that change, most people believe it will be bankrupt by the year 2030.

"Anyone who can do, much can to, you that Social Security is in deep trouble. There have to be changes made to Social Security and there are a lot of plans being floated around. I do think, though, it will still be a Social Security option. It will not be the same in the future as it is today. It cannot be. The math shows it becoming bankrupt. We're very hopeful that there will be potential for a partial privatization of Social Security where the basic underlying coverage is there, but part of one's Social Security deduction goes into an account for you as an individual. To me that's very, very positive and again presents another opportunity, if structured the right way, for organizations like Fidelity," said

Bob Reynolds, President of Fidelity Investment Retirement Group (FIRG). (See accompanying article for an interview with Reynolds about the Institutional side of retirement.)

Neal E. Cutler, director of the Boettner Center of Financial Gerontology at the University of Pennsylvania, says the changes in Social Security fuel the need for people to become more "financially literate" earlier in their lifetimes.

"For most people the accumulation stage is shorter and the expenditure stage is longer than was the case for their parents and grandparents. Because job histories, earnings, pensions, taxes, and public programs are becoming more complex, the challenge is to have more people become financially literate earlier," Dr. Cutler said.

"It's interesting," said Hopkins, "most people think about retirement as a stressful environment – what they don't think enough about is the risk of outliving their retirement savings – that's the real retirement risk."

The road to retirement is paved with IRAs and 401(k)s

Promoting financial literacy and getting investors to use various retirement vehicles are key goals for Fidelity. The company has not only focused on the accumulation phase of customer retirement savings efforts, but also on helping customers figure out appropriate ways to take their retirement assets out. "Equally as important as saving for retirement and investing this money wisely, is creating a sound retirement income plan that will last your entire retirement – which could be 30 years or more," Hopkins said.

Fidelity has had to examine the entire life plan of a customer to ensure that it has the appropriate products and services to meet everyone's needs in every stage. This examination has created a complete array of products and services for the customer.

Fidelity offers IRAs, SEP-IRAs, SARSEPs, Rollover IRAs, 401(k), 403(b)s, Keoghs, Fidelity Defined Benefit plans, 457 plans, government thrift plans, individual retirement annuities, and non-prototype plans. These arms create a lot of work for retirement specialists and others who have to answer questions about the various retirement financial instruments. Fidelity employs 107 retirement specialists, 9 retirement managers, 75 "Pipeline" general representatives, all of whom answered 484,000 calls concerning retirement in 1995. (Institutional representatives answer questions about 401(k)s and 403(b)s, 457s, and government thrift plans. The annuity group fields calls about annuities.)

Ellen Feinsand, vice president in charge of retail retirement marketing, says Fidelity is working on bridging gaps between Fidelity's institutional and retail divisions. She cites two initiatives that are helping to make retirement issues adhere to the one Fidelity concept.

The services for Existing Employees program (SEE) is designed to assist employees who are leaving institutional plans and are choosing to roll over their IRAs and become Retail retirement customers. We're trying to retain those assets and provide service to those exiting employees when they retire or change jobs. We want to make that effort very streamlined and simple and keep behind the scenes those components which don't add value for the customer. Customers don't really care that we have three options or four phone groups, etc. Customers think of all our products and services as just 'Fidelity.' So, over the course of 1996, we will be doing lots of things to make the linkage quicker, easier, and less confusing," Feinsand said.

Another key initiative, according to Feinsand, is the Central Resource Function. "This function is designed to direct clients or prospects, who are companies or employers, to meet their employees' other needs. The employees may be exiting or may want additional information on services from us," she said. For example, this additional information may involve seminars on retirement vehicles or retirement planning. "The Central Resource Function is designed to make the connection within the company invisible to the user of our services," she said. "If a customer comes in the wrong door to Fidelity, it shouldn't be their job to find the right one. It should be our job and that's what the Central Resource Function does."

There are also two retirement reference experts who update on-line retirement manuals daily with the latest changes and additions in policies and procedures. Arnold Pollinger, retirement reference expert and a former ERISA lawyer, says retirement issues have grown extremely complex.

"It took us ten years to win a book developing all of Fidelity's retail retirement policies and procedures, and even now we're still adding to it, changing it and clarifying it every day," Kaye Mulvaney, retirement reference expert, says that providing detailed information about benefits and distributions in the case of the death of one's spouse, for example, "gives us a real opportunity to help beneficiaries make informed financial decisions during what could be the most difficult time in their lives. The retirement specialists and the Legal Heirs Gate take a lot of pride in helping a customer get through this difficult time period," Mulvaney said.

Retirement business is 'seasonless'

Fidelity, according to Hopkins, is not just in the retirement business; the retirement business *is* Fidelity. Last year's Retail sales figures support her view. Retirement represented 51 percent of new accounts and 65 percent of retail net sales. Total retirement fund assets, which were only 29 percent of retail assets in 1995, have skyrocketed to reach 40 percent of total retail assets in 1995. Add to these figures the fact that the 401(k), 403(b), FIRSCo and Trust buyers are predominantly retirement – and you begin to see the importance of retirement to the Fidelity franchise.

"I think there's a widely held misconception that the retirement business only happens between January 1st and April 15th. Years ago that was the case, where the bulk of the business came in during that period because people were making deductible IRA contributions. Since then we've seen an enormous shift in the business in that the bulk of the money that comes in for retirement flows in after April 15. It's not a seasonal business, it's a seasonless business, with Transfers and Rollover IRAs flowing into the complex year-round," Hopkins said.

The world of work continues to evolve as people save for what they hope will be the times of their lives. But it is at that very point when someone's work ends that the benefit of investing with Fidelity truly begins. Fidelity's business is to help people ensure that such retirement beginnings last a lifetime.

ART DIRECTORS: Melinda Beck, Laurie Hinzman

DESIGNER/ILLUSTRATOR: Melinda Beck

STUDIO: Melinda Beck Studio, New York City, NY

CLIENT/PRODUCT: Nick at Nite/cable TV

TYPEFACES USED: Currituck, Megee Floridian, Yakovenko Picnic, Caruso Roxanna, Poplar, Logger, Bell Gothic, Rockwell

SOFTWARE: QuarkXPress, Adobe Illustrator, Adobe Photoshop

COLORS: Four, process

CONCEPT: The design of this piece for Nick at Nite—a cable station featuring television shows from the fifties and sixties—is inspired by the graphics of this time period.

SPECIAL TYPE TECHNIQUES: "I wanted the type to have an authentic 1950s look," says designer Melinda Beck. "However, I found that computer fonts were not sufficient, so I supplemented these by having some photo-lettering typeset. Many of these photo-lettering fonts were actually created in the 1950s."

SPECIAL PRODUCTION TECHNIQUES: To create the authentically retro look of this piece, says Beck, "the computer-generated artwork and type was supplemented with photo-lettering and art created with charcoal and a paintbrush. This type and artwork was then scanned in and combined with the computer-generated art and type."

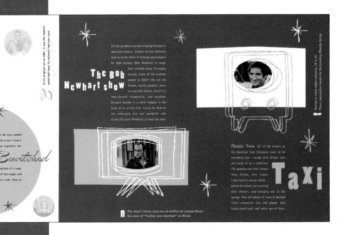

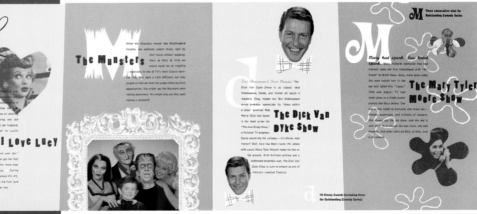

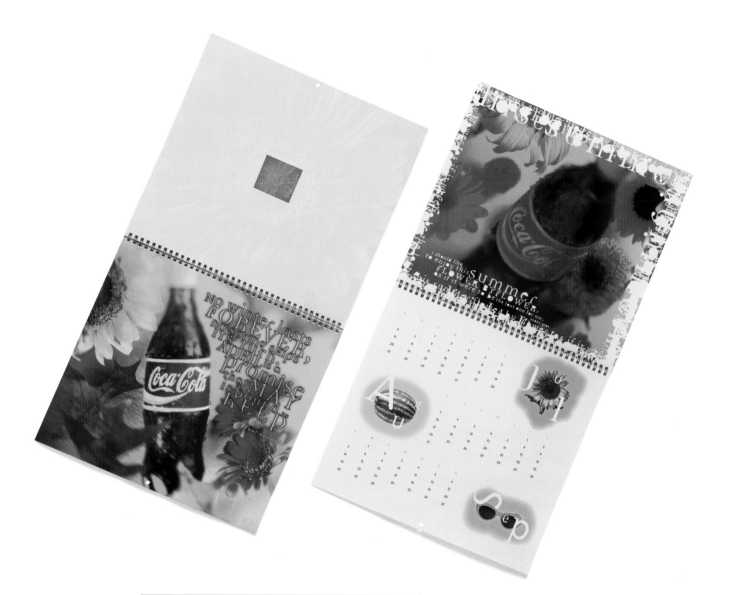

COCA-COLA CALENDAR

ART DIRECTOR/DESIGNER: Michael Taylor

STUDIO: Merge, Atlanta, GA

CLIENT/PRODUCT: Coca-Cola/soft drinks

PHOTOGRAPHER: Steve Pelosi

TYPEFACES USED: Template Gothic, Democratica, Democratica Bold, Dead History, Adobe Bellevue

TYPE DESIGNERS: Barry Deck (Template Gothic), Miles Newlyn (Democratica and Democratica Bold), P. Scott Makela (Dead History)

SOFTWARE: Adobe Illustrator, Adobe Photoshop

COLORS: Four, process, plus two, match

PRINT RUN: 1,000

CONCEPT: For this calendar, which was distributed by Coca-Cola to its employees, designer Michael Taylor grabbed the opportunity to "do something beautiful without the 'sell Coke' message." To that end, he says he "used a famous quote for each sea-son, and used photography and type to create an illustration of each season. For example, the type in the winter spread suggests wind and snow." He adds that his notion was to use type "almost as a painting technique; for example, the type spirals out of the flower for spring with the same motion I would use if I had a paintbrush with color."

SPECIAL PRODUCTION TECHNIQUES: "All seasonal spot photos began as black and white—I wanted to give the photos my own color palettes; although the final images look as if they were shot in color, they have an intriguing color palette that would not otherwise have existed if shot in color."

SPECIAL COST-CUTTING TECHNIQUES: "Special hag-gling technique used on photographer to work cheap—you know, the familiar 'think of all the exposure you'll get from such a cool piece!' line."

ART DIRECTOR: Clifford Stoltze

DESIGNERS: Clifford Stoltze, Wing Ngan

STUDIO: Stoltze Design, Boston, MA

CLIENT: Castle von Buhler Records

ILLUSTRATOR: Richard Leighton (logo typeface design)

TYPEFACES USED: Base 9, Cyberotica, Isonorm

TYPE DESIGNER: Zuzana Licko (Base 9)

SOFTWARE: QuarkXPress, Adobe Illustrator, Adobe Photoshop, Pixar Typestry

COLORS: Four, process

PRINT RUN: 3,000

COST PER UNIT: $1

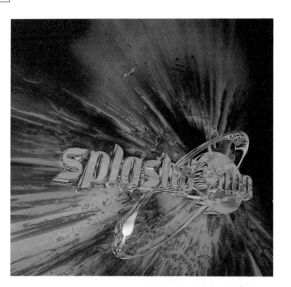

CONCEPT: This CD design for a new band called Splashdown "needed to make a splash and look professional," says designer Clifford Stoltze.

INSPIRATION: "The name of the band and the music," says Stoltze.

SPECIAL PRODUCTION TECHNIQUES: The backgrounds were created in Photoshop.

SPECIAL TYPE TECHNIQUES: The Splashdown logo was a custom digital creation, created in Typestry, that makes reference to the typeface Cyberotica and is used with it on the cover.

SPECIAL COST-CUTTING TECHNIQUES: The piece was printed on a side of another job that would have otherwise been trimmed and discarded.

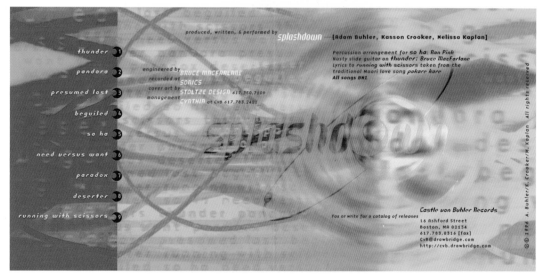

ART DIRECTOR/DESIGNER: Jonathan
Hoefler

STUDIO: The Hoefler Type Foundry,
New York, NY

CLIENT: Julie Holcomb Printers

TYPEFACES USED: HTF Didot

TYPE DESIGNER: Jonathan Hoefler
(HTF Didot)

SOFTWARE: Fontographer, Adobe
Illustrator

COLORS: Three, match

PRINT RUN: 750

COST PER UNIT: $3

CONCEPT: "Didot is an interpretation
of the types cut by late eighteenth-
century typefounder Firmin Didot
(1764-1836), punchcutter, printer
and third-generation heir to a
great French printing dynasty,"
says Jonathan Hoefler of the type-
face that is the centerpiece of this
poster. "In 1784, Didot cut what is
generally considered to be the first
typeface of the Modern genre,
characterized by horizontal stress
and flat serifs." HTF Didot was
designed by Jonathan Hoefler for
the 1992 redesign of *Harper's
Bazaar*, art directed by Fabien
Baron. "Since these faces were
intended to rationalize the work of
a rational typographer, they are
not recreations of specific origi-
nals, but instead a synthesis of
Didot's work," says Hoefler.

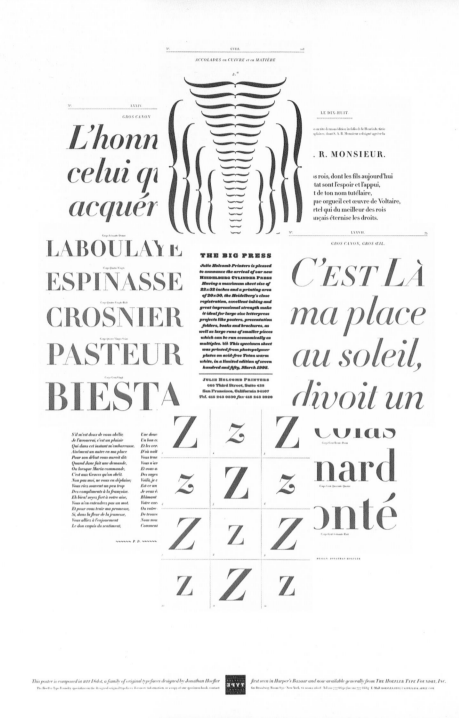

ART DIRECTOR: Andy Cruz

DESIGNER: Allen Mercer

STUDIO: Brand Design Co., Inc./
House Industries, Wilmington, DE

CLIENT/PRODUCT: *Emigre*/design trade
magazine

ILLUSTRATORS: Ken Barber, Jeremy Dean

TYPEFACES USED: House Gothic Bold, Horatio

TYPE DESIGNER: Allen Mercer (House Gothic
Bold)

SOFTWARE: Adobe Illustrator

COLORS: Three-over-one plus varnish, match

PRINT RUN: 7,000

CONCEPT: "We wanted to add cheesy, attention-grabbing
newsstand look and feel to the usually staid cover of
Emigre," says Rich Roat of Brand Design Co./House
Industries. Roat feels the concept worked because "the maga-
zine ended up in the automobile section of many newsstand
racks—a place we think most design publications should appear."

SPECIAL TYPE TECHNIQUES: Allen Mercer created the House Gothic
typeface through conventional drawing methods and digitized it in
Adobe Illustrator.

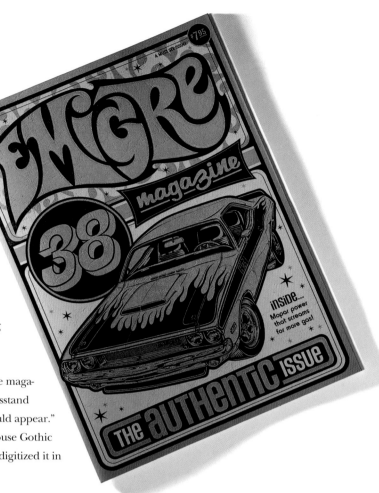

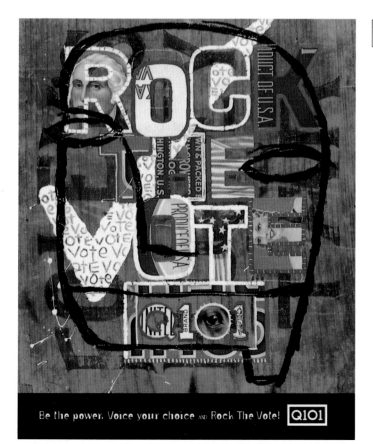

ART DIRECTOR/DESIGNER: Carlos Segura

STUDIO: Segura, Inc., Chicago, IL

CLIENT: Q101 Radio

ILLUSTRATOR: Kirk Richard Smith of
Firehouse 101

TYPEFACE USED: Colony

TYPE DESIGNER: Marcus Burlile (Colony)

SOFTWARE: QuarkXPress, Adobe Photoshop,
Adobe Illustrator, Ray Dream Designer

COLORS: Four, process

PRINT RUN: 8,000

CONCEPT: This sticker uses a collaged type treat-
ment to succinctly convey its message to a
young audience, the listeners of alternative-
rock station Q101.

CREATIVE DIRECTOR/FIRM: Candace Bond/Motown Records Inc.

ART DIRECTOR/DESIGNER: Margo Chase

STUDIO: Margo Chase Design, Los Angeles, CA

CLIENT: Motown Records, Inc.

PHOTOGRAPHER: Various

TYPEFACES USED: Triplex, Matrix Script, Fatboy

TYPE DESIGNERS: Zuzana Licko (Triplex, Matrix Script), Margo Chase (Fatboy)

SOFTWARE: Adobe Illustrator, Adobe Photoshop, QuarkXPress

COLORS: Four, process, plus one, match

CONCEPT: The color palette and use of layered type in this booklet for a Marvin Gaye CD box set was inspired by Gaye's music.

INSPIRATION: The custom-designed Fatboy font used throughout the booklet was inspired by 1970s-style "bold and ugly" fonts, according to Margo Chase.

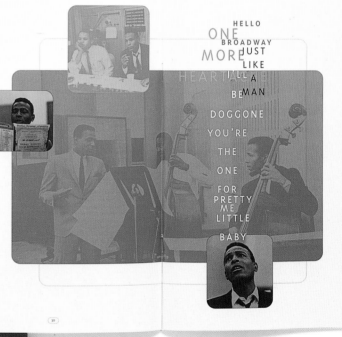

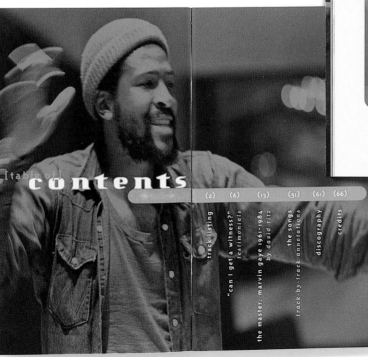

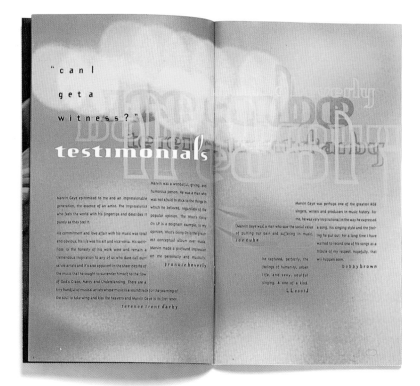

FULBRIGHT YOUNG ESSAYIST AWARD FLIER

ART DIRECTOR/DESIGNER/ILLUSTRATOR: Melinda Beck

STUDIO: Melinda Beck Studio, New York City, NY

CLIENT/PRODUCT: Scholastic/children's book and magazine publishers

TYPEFACES USED: Trixie, Bell Gothic

TYPE DESIGNER: Erik van Blokland (Trixie)

SOFTWARE: QuarkXPress, Adobe Illustrator, Adobe Photoshop

COLORS: Four, process

CONCEPT: This primarily typographic design conveys the spirit of the young essayists competition it promotes by using cursive-on-loose-leaf, typewriter and computer typography to suggest the range of "media" the essayists might be working in. The spot illustrations convey the subject of the essay contest: international and cross-cultural issues.

INSPIRATION: "Alvin Lustig's book cover designs," says designer Melinda Beck.

SPECIAL TYPE TECHNIQUES: "I scanned some of my own cursive handwriting on loose-leaf paper and the *N* key from my computer keyboard," says Beck.

SPECIAL COST-CUTTING TECHNIQUES: The photos of the monuments were from a Dover copyright-free clip art book.

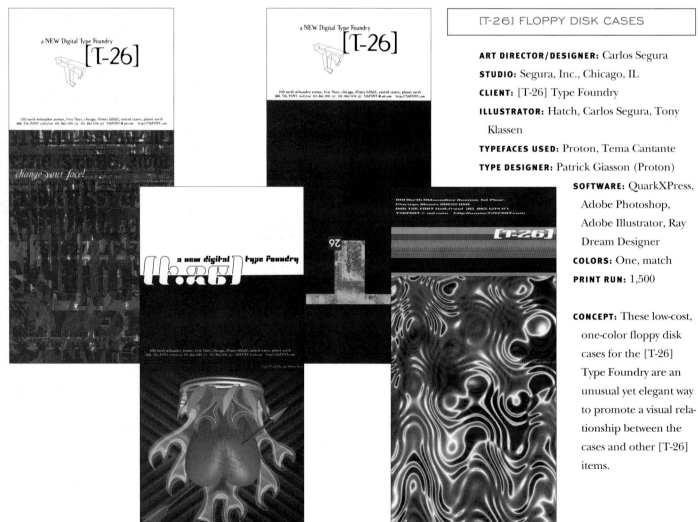

[T-26] FLOPPY DISK CASES

ART DIRECTOR/DESIGNER: Carlos Segura

STUDIO: Segura, Inc., Chicago, IL

CLIENT: [T-26] Type Foundry

ILLUSTRATOR: Hatch, Carlos Segura, Tony Klassen

TYPEFACES USED: Proton, Tema Cantante

TYPE DESIGNER: Patrick Giasson (Proton)

SOFTWARE: QuarkXPress, Adobe Photoshop, Adobe Illustrator, Ray Dream Designer

COLORS: One, match

PRINT RUN: 1,500

CONCEPT: These low-cost, one-color floppy disk cases for the [T-26] Type Foundry are an unusual yet elegant way to promote a visual relationship between the cases and other [T-26] items.

ART DIRECTOR/DESIGNER: Scott Mires

STUDIO: Mires Design, San Diego, CA

CLIENT/SERVICE: Communications Arts Group/San Diego creative association

ILLUSTRATORS: Gerald Bustamante (cover); Scott Mires (interior illustrations)

TYPEFACES USED: Hand-rendered calligraphy, collage

TYPE DESIGNER: Scott Mires (hand-rendered)

COLORS: Four, process over one, match

PRINT RUN: 1,500

CONCEPT: This invitation to a creative association's party worked because "it was refreshing to see something so naive and raw," says Scott Mires. "Humor is something that is often forgotten in direct mail and I felt that it really made this piece effective. Also, being so close to this industry allowed me a free hand to poke fun at it."

INSPIRATION: Mires describes this piece as "a response to all of the computer-produced work. I wanted to do something that was very immediate and fun. Spontaneity is something that the computer oftentimes discourages, so I reverted to old-fashioned art boards. I wrote the copy without editing (or even thinking too much) and just tried to have fun."

SPECIAL PRODUCTION TECHNIQUES: The invitation required no typesetting or layout—Mires went directly to camera-ready art.

ART DIRECTOR: Antero Ferreira

DESIGNERS: Jorge Serra, Celestino Fonseca

STUDIO: Antero Ferreira Design, Oporto, Portugal

CLIENT: IEFP (Portugal) and European Community (EC)

ILLUSTRATORS: Joana Alves, Eduardo Sottomayor, Celestino Fonseca, Antero Ferreira

TYPEFACES USED: Officina, Novarese

TYPE DESIGNER: Eric Spiekermann (Officina)

SOFTWARE: Macromedia FreeHand, Adobe Photoshop

COLORS: Four, process

PRINT RUN: 1,500

COST PER UNIT: $1

CONCEPT: This flier promotes the Mediateca desktop publishing manual and video; since Antero Ferreira Design did the manual the flier promotes, they used their own work—work also included in the manual—to illustrate each letter of the title. This concept effectively conveys the quality and range of design examples included in the manual.

ART DIRECTORS/DESIGNERS:
Phil Yarnall, Stan Stanski

STUDIO: Smay Vision, Inc., New
York, NY

CLIENT: Smay Vision, Inc.

TYPEFACES USED: Duh,
Chunkstyle

TYPE DESIGNERS: Phil Yarnall
and Stan Stanski (Duh,
Chunkstyle)

SOFTWARE: QuarkXPress,
Adobe Photoshop

COLORS: Four, process

CONCEPT: This self-promotional
ad for Smay Vision worked because "we thought it was pretty cool—and didn't make us
look like we take ourselves too seriously," say Phil Yarnall and Stan Stanski.

INSPIRATION: "Based on our 'Smay Vision/X-Ray Specs' logo and a similar ad for them
that we 'borrowed' from an ancient detective magazine."

SPECIAL TYPE TECHNIQUES: The typeface Duh "originated as a few letters on a rusted-out
gas station sign behind a prison in upstate Pennsylvania," says Phil Yarnall. "I made my
parents pull the car over, took a picture and then re-created the missing letters with
Photoshop." The typeface Chunkstyle "comes from those little rubber-stamp return
address things, that, when blown up, look really cool as type."

ART DIRECTORS/DESIGNERS: Nancy Mazzei, Brian Kelly

STUDIO: Smokebomb, Brooklyn, NY

CLIENT: *KGB Magazine*

PHOTOGRAPHERS: Benoît Peverelli (Tricky), Renata Lobbedey (Cheri)

TYPEFACES USED: Backspacer (logotype), manipulated type

TYPE DESIGNER: Smokebomb (Backspacer)

SOFTWARE: QuarkXPress, Adobe Photoshop

COLORS: Four, process

PRINT RUN: 25,000

CONCEPT: This cover design for *KGB Magazine* is "an accurate visual represen-
tation of the content," says designer Brian Kelly.

INSPIRATION: "At the time of release, the Unabomber was all over the TV,"
says Kelly. "Since a large number of issues are mailed, we played off of the
post office's stamp typography and wrote the cover text with a lot of words
like *bomb, invasion, blows up, delivers, enclosed,* and *explodes!*"

SPECIAL TYPE TECHNIQUES: The cover type was created from several existing
fonts and cut and pasted—via photocopying and Photoshop—to form the
text boxes.

ART DIRECTOR/DESIGNER: Elliott Peter Earls

STUDIO: The Apollo Program, Greenwich, CT

CLIENT/PRODUCT: Elliott Peter Earls/music, multimedia and typography

ILLUSTRATOR: Elliott Peter Earls

PHOTOGRAPHER: Elliott Peter Earls

TYPEFACES USED: IdolKing (main title font), Toohey & Wynand (secondary font)

TYPE DESIGNER: Elliott Peter Earls (all fonts)

SOFTWARE: Adobe Photoshop, Macromedia FreeHand, Fontographer

COLORS: Four, process

PRINT RUN: 5,000

COST PER UNIT: $1.25

CONCEPT: This self-generated project was inspired by Henry Miller's "On Writing," says Elliott Peter Earls of The Apollo Program.

SPECIAL TYPE TECHNIQUES: "IdolKing and Toohey & Wynand were created by drawing characters on loose-leaf paper, scanning them into Fontographer and then turning them into vector-based characters," says Earls.

SPECIAL PRODUCTION TECHNIQUES: The piece incorporated extensive digital manipulation of the original photograph, as well as substitution of Day-Glo yellow and Day-Glo magenta for process yellow and magenta.

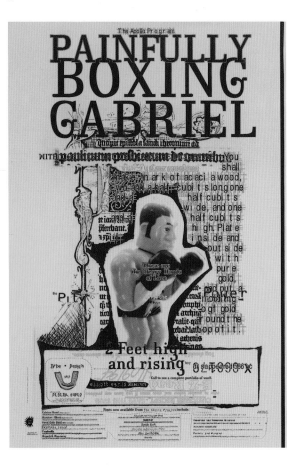

ART DIRECTOR/DESIGNER: Elliott Peter Earls

STUDIO: The Apollo Program, Greenwich, CT

CLIENT/PRODUCT: Elliott Peter Earls/music, multimedia and typography

ILLUSTRATOR: Elliott Peter Earls

PHOTOGRAPHER: Elliott Peter Earls

TYPEFACES USED: Calvino Hand Family (title font), Penal Code (secondary font)

TYPE DESIGNER: Elliott Peter Earls (all fonts)

SOFTWARE: Adobe Photoshop, Macromedia FreeHand, Fontographer

COLORS: One, black

PRINT RUN: 5,000

COST PER UNIT: $1

CONCEPT: "On a structural level this piece was an attempt to create a micro-mythological system, while on a thematic level it was an attempt to *wrestle* (box) with ideas of artistic inspiration," says Elliott Peter Earls of this poster.

SPECIAL TYPE TECHNIQUES: As with the piece above, the typefaces were created by scanning hand-drawn typefaces into Fontographer and then turning them into vector-based characters.

+ THE ALTERNATIVE PICK +

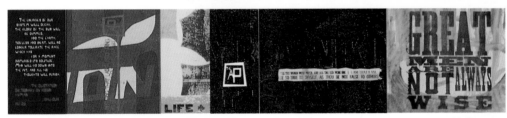

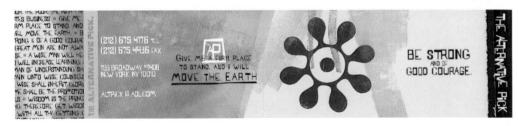

"ALTERNATIVE PICK" BOOK AND CAMPAIGN

ART DIRECTOR/DESIGNER: Carlos Segura

STUDIO: Segura, Inc., Chicago, IL

CLIENT/PRODUCT: *The Alternative Pick*/sourcebook

ILLUSTRATORS: Jordan Isip, Hatch, Carlos Segura

TYPEFACES USED: Boxspring, Mattress, Colony

TYPE DESIGNERS: Carlos Segura and Scott Smith (Boxspring, Mattress), Colony (Marcus Burlile)

SOFTWARE: QuarkXPress, Adobe Photoshop, Adobe Illustrator, Ray Dream Designer

COLORS: Four, process, plus two, match

PRINT RUN: 10,000, plus 500 limited edition

CONCEPT: Using "life" as the theme, and using quotations about life as visual centerpieces, this *Alternative Pick* book and campaign uses exuberant type treatments to celebrate the joy of the creative process.

SPECIAL PRODUCTION TECHNIQUES: Various pieces of the campaign were letterpressed; others featured multi-level blind-embossing or 200-line silkscreen.

ART DIRECTOR/DESIGNER: Greg Lindy

STUDIO: REY International, Los Angeles, CA

CLIENT/SERVICE: Young Musicians Foundation/ youth symphony

TYPEFACES USED: Trump Kuenstler 480, Helvetica Round, Goudy Clip

TYPE DESIGNER: Greg Lindy (Goudy Clip)

SOFTWARE: QuarkXPress, Adobe Photoshop

COLORS: Two, match

PRINT RUN: 7,000

CONCEPT: The client, a youth symphony, needed a brochure "to generate excitement and to raise concert attendance," according to designer Greg Lindy. This brochure uses a layered type treatment "to capture the many levels of sound (information) that exist in classical music," says Lindy. "The object was to create rhythm with moments of fury, yet always remaining legible in its message." The use of metallic ink adds an appropriately seasonal touch.

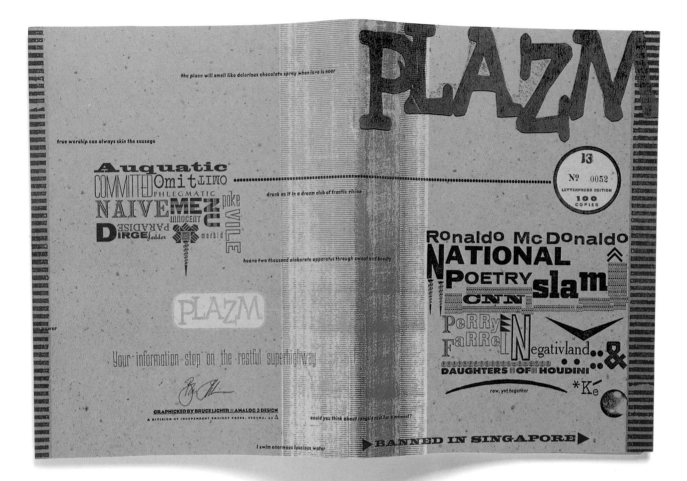

PLAZM #13 COLLECTOR'S EDITION COVER

ART DIRECTOR/STUDIO/LOCATION: Pete
McCracken/Plazm Media/Portland, OR

DESIGNER/STUDIO/LOCATION: Bruce
Licher/Independent Project Press/Sedona, AZ

CLIENT/PRODUCT: Plazm Media/magazine, digital
type foundry, design group

TYPEFACES USED: Multiple lead faces

COLORS: Six

PRINT RUN: 100

COST PER UNIT: $7.50

CONCEPT: "The concept and copy [of this issue]
revolve around the 1996 National Poetry Slam,"
says Pete McCracken. "Plazm was the image and
marketing directors for the event. Bruce [Licher]
used words randomly generated by Plazm along
with poetry from the magnetic poetry set on his
fridge as cover copy."

INSPIRATION: "Andy Warhol's early magazine efforts
using silkscreen posters, multiple inserts and flexi-
disks were a source of inspiration."

SPECIAL PRODUCTION TECHNIQUES: "We wanted to
do an edition of the magazine that contained
handmade components that would make each
copy unique," says Pete McCracken, "so Bruce
Licher was commissioned to create Plazm's first
collector's edition. The edition is individually
letterpress-printed, signed and numbered, and
then packaged with a limited edition T-shirt
(individually numbered to correspond with each
magazine), a 45 single with letterpress sleeve and
a silkscreened announcement poster. The cover
art was printed in two versions: one with a wrap-
around cover for this edition, and the second as a
front cover only. The latter was scanned and
reproduced for our newsstand litho version."

CONCEPT

TYPE

IMAGE

LAYOUT

Unlike type—which is a necessity in almost every design—you *can* have a design without an image. You can also have your cake without frosting, your car without air-conditioning and your TV without color.... But why would you *want* to?

In this section you'll see:

• how Tom DeMay Jr. of *Internet Underground* used scanned-in flowers and a liberal application of Wite-Out on an old book to come up with a striking design for a feature story about a right-to-die Web site.

• how Sonia Greteman used torn photographs as the visual centerpiece for a handicapped training center's annual report.

• how Thomas Scott used an image of a floppy disk on fire to convey an anti-technology message in his self-promotional ad for a sourcebook.

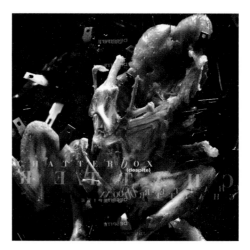

CHATTERBOX "DESPITE" CD

ART DIRECTOR/DESIGNER/PHOTOGRAPHER: Thomas Wolfe

STUDIO: Kerosene Halo, Chicago, IL

CLIENT: Tooth and Nail Records

TYPEFACES USED: Bauer Bodoni, Univers, Minion

SOFTWARE: Adobe Illustrator, Adobe Photoshop, QuarkXPress

COLORS: Four, process, plus one, match

PRINT RUN: 10,000-15,000

CONCEPT: "Chatterbox is an industrial band whose music is extremely dark and aggressive, but with lyrics that reflect a glimpse of hope," says designer Thomas Wolfe. "We thought that their name and the title of the album, *Despite*, could be used to describe this duality. The word *chatterbox* meant to us a grinding talkativeness with the effect of one's words eating away at you, right to the bone. While at a Thanksgiving dinner, the concept of using that night's remains as the primary image came to us. We believed that reproducing this image in a monochromatic tone would also elevate it to the status of fine art rather than an expression of mere shock. The band and their record label loved the idea, but unfortunately the label's distributor stated that they would not carry the product with this cover" (shown top right).

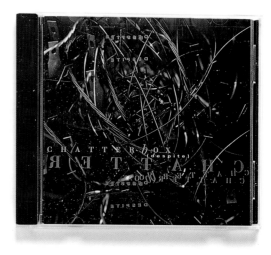

With the deadline for the completion of the project looming, Wolfe says, "We came up with the concept of using razor blades and an abstract wire sculpture to symbolize teeth and the way words can cut through so much chaos to get to the heart of the matter. Though our original cover was not used, we were able to include several abstracts from those images to reinforce our initial concepts. Finally, as a statement against the censorship of our client and of ourselves, we created a message that is discreetly hidden underneath the tray of the CD."

SPECIAL PRODUCTION TECHNIQUES: "To add to the rough nature of the subject, we decided to use scanography instead of traditional photography of the stills. This meant composing and lighting all our images directly on our scanner. To protect our scanner, we placed all the objects on a clear piece of acetate that was intentionally layered with dust to contribute to the gritty nature of this project."

ART DIRECTOR/DESIGNER: Tom DeMay, Jr.

CLIENT: *Internet Underground* magazine

ILLUSTRATOR: Polly Becker

TYPEFACES USED: Adobe Garamond (head), Sabon (body)

SOFTWARE: QuarkXPress, Adobe Photoshop

COLORS: Four, process

CONCEPT: According to Tom DeMay, Jr., "The inspiration for the layout came from the purchase of a book on the astral plane picked up from a junk store for $0.50. The book and footnotes from it were incorporated into the final layout, along with Wite-Out and various other handwritten notes."

SPECIAL PRODUCTION TECHNIQUES: "Applying a good deal of Wite-Out to an old book, and scanning in dried flowers directly."

The Art and Science of Dying Well

art by Polly Becker

by John Hofsess

A former journalist explains how a compelling obituary led to the creation of DeathNET
http://www.rights.org/deathnet

ART DIRECTOR/DESIGNER: Lori Siebert

STUDIO: Siebert Design Associates, Cincinnati, OH

CLIENT/SERVICE: James Tarbell/benefit coordinator

ILLUSTRATOR: Lori Siebert

TYPEFACES USED: Various, hand-lettering

COLORS: Four, process

CONCEPT: Inspiration for these postcard invitations to the Odd Ball, an event that was held in conjunction with the Over-the-Rhine Heritage Festival, was drawn from popular advertising cards of the early 1900s—a period also celebrated by the Heritage Festival. The distinct look of the postcards coordinated well with the event poster; the fact that recipients got a set of postcards, each bearing more information about the event, made the invitation package interactive.

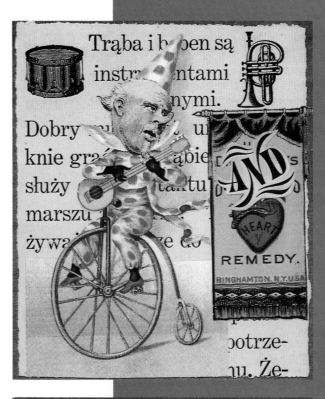

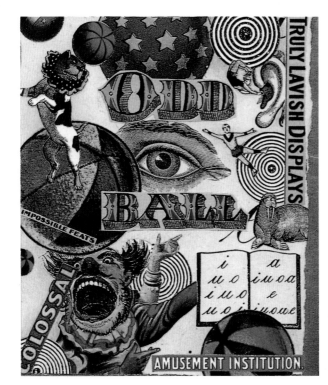

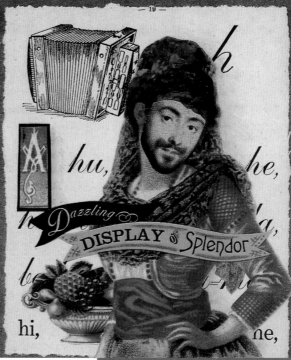

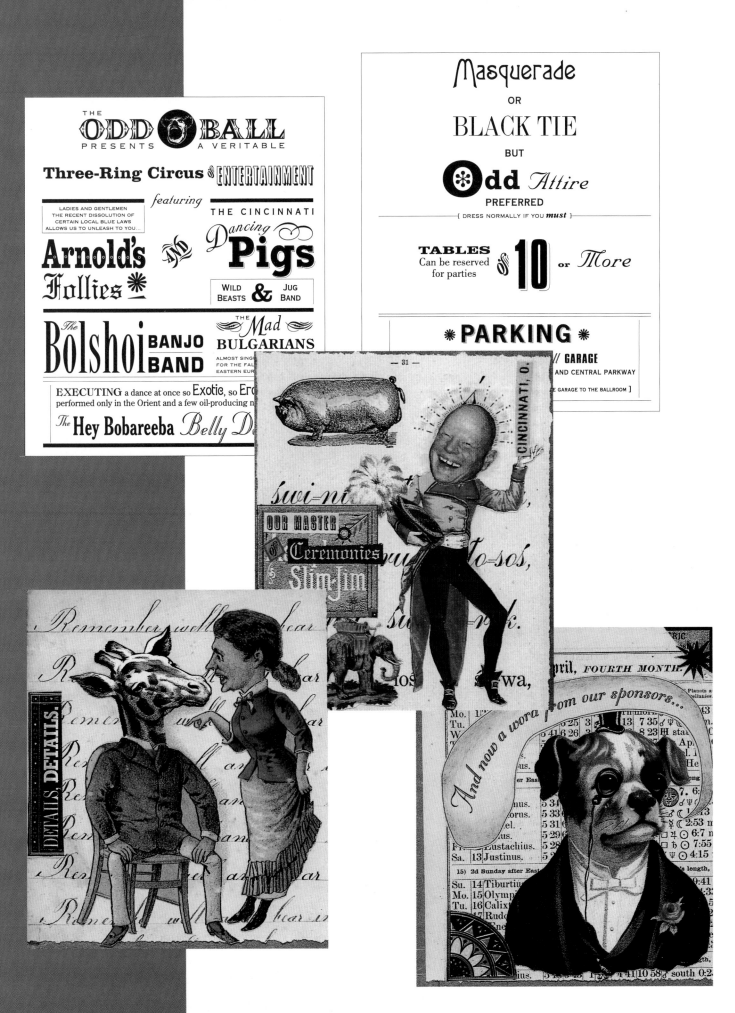

"ICED" COVER

ART DIRECTOR/DESIGNER/ILLUSTRA-TOR: Paul Buckley

STUDIO: Penguin USA, New York, NY

CLIENT/SERVICE: Penguin USA/book publishing

SOFTWARE: Adobe Illustrator

COLORS: Four, process, plus one, match

PRINT RUN: 7,500

CONCEPT: The novel's plot—"about a paranoid crackhead who rambles in this constant monologue," says Paul Buckley—drove this book cover design. "I needed an image, went in to Illustrator to play with all the then-new commands and filters, and came up with this," says Buckley. Though the author and agent disliked the design, the editor managed to push it through the approval process anyway.

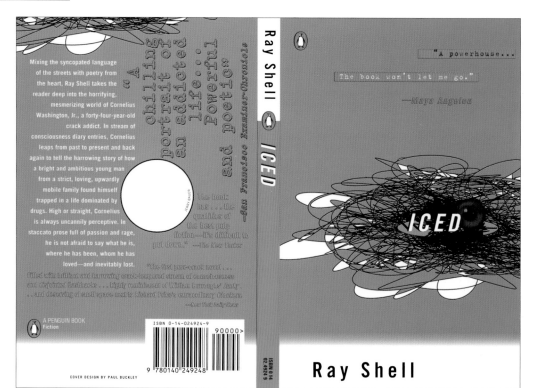

TREVIN PINTO RECITAL INVITATION

ART DIRECTOR/DESIGNER: Greg Lindy

STUDIO: REY International, Los Angeles, CA

CLIENT/SERVICE: Trevin Pinto/guitarist

TYPEFACES USED: Helvetica Round

SOFTWARE: QuarkXPress

COLORS: Two, match

PRINT RUN: 250

COST PER UNIT: $0.50

CONCEPT: The graphic that is the centerpiece of this invitation to a guitar recital was used because "one of the pieces performed was entitled 'Clocks.' Also, the guitar itself became a graphic element in the portrayal of it as the band across the card," says Greg Lindy. Lindy feels this approach worked because "guitar recitals are usually somber events, but this invitation generates excitement and curiosity. The graphic elements create mystery and hopefully brought attendees to the recital."

SPECIAL PRODUCTION TECHNIQUES: Metallic silver was used to highlight some graphic elements.

HEAVYSHIFT "LAST PICTURE SHOW" CD

ART DIRECTORS/DESIGNERS/ILLUSTRATORS: Karen
L. Greenberg, D. Mark Kingsley

STUDIO: Greenberg Kingsley, New York, NY

CLIENT: Discovery Records

TYPEFACES USED: Helenic, Folio

SOFTWARE: Adobe Illustrator, Adobe Photoshop,
QuarkXPress, Adobe Streamline

COLORS: Four, process

CONCEPT: "The client wanted the piece to unfold
into a 'story' about filmmaking," says Karen L.
Greenberg, a treatment which fit the title of the
CD. "The original brief referred to lounge/cock-
tail culture as well."

INSPIRATION: "Movie production iconography: The
line drawings were inspired by old film stills and
memory," says Greenberg.

SPECIAL PRODUCTION TECHNIQUES: Hand-drawn
illustrations were scanned in and autotraced in
Adobe Streamline, and then imported into
Photoshop for further manipulation and layering.

SPECIAL COST-CUTTING TECHNIQUES: The piece was
illustrated by the designers.

PUBLISHER: Peter Morton

CREATIVE DIRECTOR: Warwick Stone

CREATIVE DIRECTION: Warwick Stone, Margo Chase

DESIGN AND EDITORIAL: Margo Chase, Terry Stone, Brian Hunt, Dave McClain

ILLUSTRATION: Brian Hunt

STUDIO: Margo Chase Design, Los Angeles, CA

CLIENT: Hard Rock Hotel & Casino

HTML AND PRODUCTION: Yeeeoww! Digital Cartoons

PROGRAMMING: Creative Internet Design (CID); Joe Cates, Ari Prochazka

PHOTOGRAPHERS: Peter Dokus, Margo Chase

QTVR: Axis Images, Janie Fitzgerald

CONTRIBUTORS: Jane Bogart, Linda Foreman, Pleasant Gehman, Michael Kaplan

TYPEFACES USED: Magneto, Steile Futura, custom-designed

SOFTWARE: Adobe Photoshop, Adobe Illustrator

CONCEPT: This Web site for Hard Rock America's hotel and casino (located at http://www.hardrock. com) successfully combines a Las Vegas feel with the sophistication of the hotel itself.

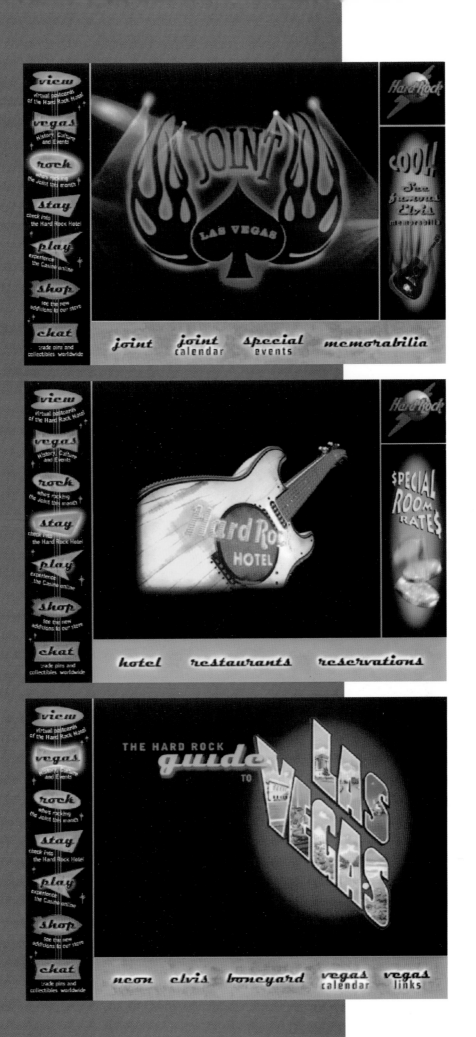

FEBRUARY/MARCH COOLER CALENDAR

ART DIRECTOR/DESIGNER/ILLUSTRATOR: Melinda Beck

STUDIO: Melinda Beck Studio, New York City, NY

CLIENT/PRODUCT: The Cooler/nightclub featuring live music

PHOTOGRAPHER: Paul Kaufman, Raffi/Van Chromes, Inc.

TYPEFACES USED: Helvetica, Madrone, Bell Gothic

SOFTWARE: QuarkXPress, Adobe Illustrator, Adobe Photoshop

COLORS: Two, match

PRINT RUN: 1,000

CONCEPT: "This piece is part of a series of monthly calendars," says designer Melinda Beck. "The client needed eye-catching visuals that looked different every month. These graphics had to be created quickly on a very small budget." Inspired by the work of Miro, Beck created metal figures to illustrate the February/March calendar.

SPECIAL PRODUCTION TECHNIQUES: "The metal dancing figures were made from scrap metal bought in surplus stores and junk shops," says Beck. "I then arranged them on a white board and had them shot from above."

ART DIRECTOR/DESIGNER: Elliott Peter Earls

STUDIO: The Apollo Program, Greenwich, CT

CLIENT/PRODUCT: Elliott Peter Earls/music, multimedia and typography

ILLUSTRATOR: Elliott Peter Earls

PHOTOGRAPHER: Elliott Peter Earls

TYPEFACES USED: Subluxation family, Bleached, Bland, Perma, Derma

TYPE DESIGNER: Elliott Peter Earls (all fonts)

SOFTWARE: Adobe Photoshop, Macromedia FreeHand, Fontographer

COLORS: One, black

PRINT RUN: 5,000

COST PER UNIT: $1

CONCEPT: "This poster represents an attempt to construct a sufficiently *charged* metaphor, as an attempt to, on a nonverbal level, lay bare the pervasive and sinister (moral) effects of the 'cathode kingdom,'" says Elliott Peter Earls. The typefaces, all of which he created himself, "were created by examining the work of the early American Christian missionaries and their attempts to create a character set for the largely phonetic Cherokee language," says Earls. "The Subluxation family is the result of an examination of the results of semantic *reintegration.*"

ART DIRECTOR: Eric Wagner

DESIGNERS: Eric Wagner, David Kaplan, Erik DeBat

STUDIO: Tanagram, Inc., Chicago, IL

CLIENT/SERVICE: MG Design/exhibit design and marketing services

ILLUSTRATORS: Eric Wagner, David Kaplan, Erik DeBat

TYPEFACES USED: Avenir

SOFTWARE: QuarkXPress, Adobe Photoshop, Macromedia FreeHand, Strata, StudioPro

COLORS: Three, match

PRINT RUN: 10,000

CONCEPT: "The billboard-like illustrations were able to say a lot while remaining simple and direct, much like an MG Design exhibit," says designer Eric Wagner. "The cover line art was used as the basis for a large-scale, three-dimensional promotional exhibit for MG Design, presented in tandem with their brochure."

SPECIAL PRODUCTION TECHNIQUES: "Images were generated in Photoshop using CMYK mode," says Wagner. "On press, MG Design's corporate match colors were substituted for process ink colors."

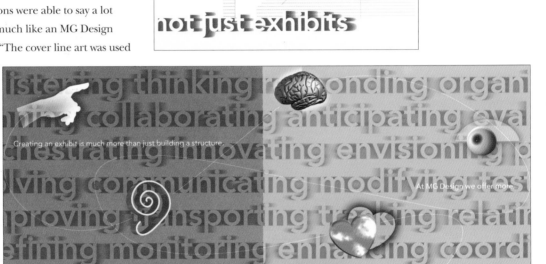

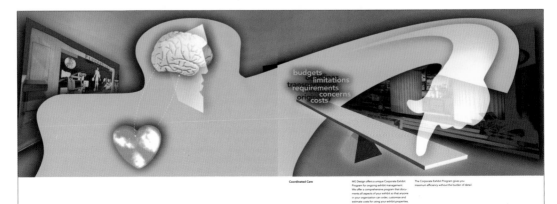

ART DIRECTORS: Jeri Heiden, A&M Records;
Michael Rey, Greg Lindy, REY International

DESIGNER: Greg Lindy

STUDIO: REY International, Los Angeles, CA

CLIENT: A&M Records

PHOTOGRAPHERS: Michael Rey, Greg Lindy

TYPEFACES USED: Helvetica, Akzidenz Grotesk,
Trump Kuenstler 480, Futura Script Round

TYPE DESIGNER: Greg Lindy (Futura Script Round)

SOFTWARE: QuarkXPress, Adobe Photoshop

COLORS: Four, process

CONCEPT: "These samplers go to people in the
industry," says Greg Lindy of these cover designs
for A&M promotional CDs. "They are inundated
with product; we wanted our samplers to be noticed. Hopefully, with
our use of odd imagery, this was the case." The concept behind the
campaign was to take various tag lines and illustrate them outra-
geously and memorably, "to let our minds go crazy, to see what solu-
tions we could come up with."

ART DIRECTOR: Jennifer Morla

DESIGNERS: Jennifer Morla, Craig Bailey

STUDIO: Morla Design, San Francisco, CA

CLIENT/PRODUCT: Levi Strauss & Co./retail clothing

ILLUSTRATOR: Various

TYPEFACES USED: Stymie Bold, Franklin Gothic Extra Extended, Linoscript, Copperplate 33BC, Kauffman, various wood typefaces

SOFTWARE: QuarkXPress

COLORS: Four, process, plus two, match

CONCEPT: "*This Is a Pair of Levi's Jeans…* is the definitive history of the Levi's 501 brand," says Koree Mathais of Morla Design. "The book lavishly illustrates the past 140 years of Levi's 501 Jeans with over 300 pages of the people, places, movements and marketing that turned one brand into an American icon. Eclectic typography, historic letters, western imagery and pull-out spreads add to its visual interest."

SPECIAL PRODUCTION TECHNIQUES: The piece includes a silkscreened chipboard cover with a tipped-in 501 tab on the foil-stamped linen spine; ¾" die-cut half-circles were included on gatefolds.

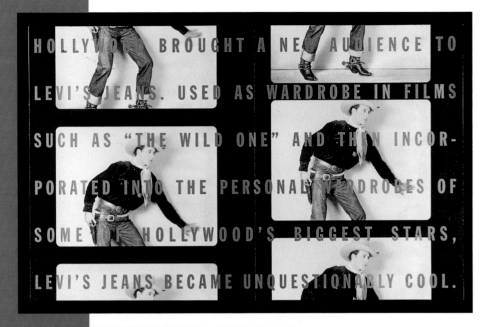

HOLLYWOOD BROUGHT A NEW AUDIENCE TO LEVI'S JEANS. USED AS WARDROBE IN FILMS SUCH AS "THE WILD ONE" AND THEN INCORPORATED INTO THE PERSONAL WARDROBES OF SOME OF HOLLYWOOD'S BIGGEST STARS, LEVI'S JEANS BECAME UNQUESTIONABLY COOL.

THE LEVI'S BRAND DOESN'T STAND FOR ONLY JEANS. FROM ITS VERY BEGINNINGS AS A MANUFACTURER, LS&CO. HAS MADE A VARIETY OF ITEMS RANGING FROM TRADITIONAL BIB OVERALLS, OVERGARMENTS KNOWN AS "JUMPERS," TO TRADITIONAL COATS.

2,500,000,000

[PAIRS OF LEVI'S JEANS SOLD SINCE 1853]

MOX "UNSUNG" CD

ART DIRECTORS/DESIGNERS/ILLUSTRATORS: Walter McCord, Mary Cawein

STUDIO: Choplogic, Louisville, KY

CLIENT/PRODUCT: Michael Boyd/CD of instrumental music

TYPEFACES USED: Neo, Bodoni Old Style

TYPE DESIGNER: Carlos Segura (Neo)

SOFTWARE: QuarkXPress

COLORS: Two, match

PRINT RUN: 5,000

COST PER UNIT: $0.15

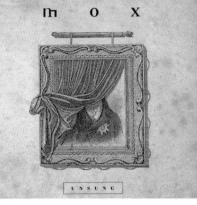

CONCEPT: This design for a CD of instrumental music—a CD appropriately entitled *Unsung*—"retains a certain ambiguity and mystery, yet relates to the album's theme," according to designer Walter McCord. "The visual strength of the cover doesn't betray a pertinence to the concept, as so often happens with album covers."

INSPIRATION: "An attempt to illustrate 'unsung' metaphorically and humorously."

SPECIAL COST-CUTTING TECHNIQUES: The use of the warmth of the paper stock's color created the look of aged paper, precluding the use of four-color printing.

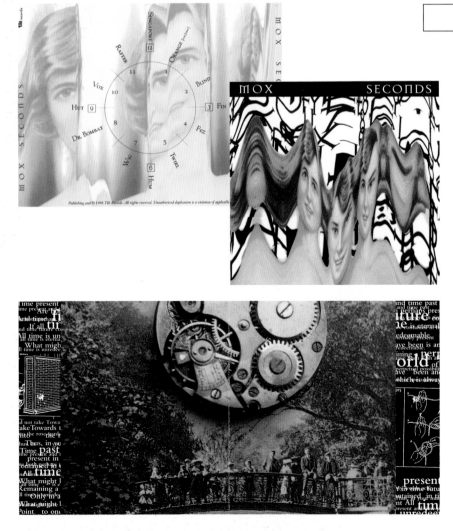

MOX "SECONDS" CD

ART DIRECTORS/DESIGNERS/ILLUSTRATORS: Walter McCord, Mary Cawein

STUDIO: Choplogic, Louisville, KY

CLIENT/PRODUCT: Michael Boyd/CD of instrumental music

TYPEFACES USED: Mason, Exocet, Janson Italic

TYPE DESIGNER: Jonathan Barnbrook (Mason, Exocet)

SOFTWARE: QuarkXPress

COLORS: Four, process

PRINT RUN: 5,000

COST PER UNIT: $0.25

CONCEPT: Designer Walter McCord felt this concept worked because "there's a rapid flow, a quicksilver poetry that evokes the music. The wavering pattern of the woman seems to form a syncopated sequence, and to that extent it's successful."

INSPIRATION: McCord says it was the music. "There is a marked tendency in this project toward experimentation to match the composer's breadth and range and to achieve something startling. We tried to find a graphic analogy to the music in the rhythmic expansions and condensations of the visual."

ART DIRECTORS/DESIGNERS: Phil Yarnall, Stan Stanski

STUDIO: Smay Vision, Inc., New York, NY

CLIENT: *Guitar Magazine*

PHOTOGRAPHER: Various

TYPEFACES USED: Canadian Photographer

SOFTWARE: QuarkXPress, Adobe Photoshop

COLORS: Four, process

PRINT RUN: 100,000

CONCEPT: "The art was originally created to be used as a cover—we needed a very bold way of showing four different female guitarists all included in one article," say Phil Yarnell and Stan Stanski of this article for *Guitar Magazine*. "The title was based on 'The Artist Formerly Known as Prince,' so it seemed like an obvious solution to use the female symbol."

They come from all walks of life, express themselves in countless ways, and command respect among their peers. They are getting as much attention as their male counterparts and are a force to be reckoned with—and acknowledged. This is not some feminist wet-dream but is, in fact, the current state of women guitarists. For the first time since guitars got plugged into amplifiers, women are equals to their axe-wielding male counterparts.

Women guitarists are no longer content to be ghettoized into "acceptable" musical categories such as folk and country, and now can be heard playing everything from heavy metal to jazz, and especially alternative rock. They are a fresh voice on the pop music scene, and are inventing new modes of expression for the guitar that could only be the result of their unique perspective. For one thing, today's women guitarists had little in the way of female role models, so their outlook on the guitar has been influenced by both sexes, something that just can't be said for most male guitarists. Women were never allowed to play by the rules, so they are often better at breaking them.

(The Guitarists formerly known as Chicks)
by Lee Sherman

PUBLISHER: Don Burdge

DESIGNERS: Margo Chase, Brian Hunt

STUDIO: Margo Chase Design, Los Angeles, CA

CLIENT/SERVICE: Burdge, Inc./printing

HTML AND PROGRAMMING: John Siska

PHOTOGRAPHER: Dave Bjerke

COPYWRITING: Don Burdge

TYPEFACES USED: Arbitrary Sans

TYPE DESIGNER: Barry Deck (Arbitrary Sans)

SOFTWARE: Adobe Photoshop, Adobe Illustrator, Adobe PageMill

BURDGE, INC. PRINTERS AND ENGRAVERS

BUSINESS STATIONERY SPECIALISTS

CONCEPT: This design for a printer's Web site (located at http://www.burdge.com) takes ordinary photographs of the printing process and, with the use of a duotone-like color treatment and rounded and shaded cropping, makes them the elegant centerpieces of this highly informational Web site.

LITHOGRAPHY

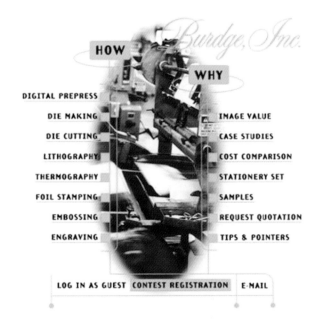

HOW

WHY

DIGITAL PREPRESS

DIE MAKING IMAGE VALUE

DIE CUTTING CASE STUDIES

LITHOGRAPHY COST COMPARISON

THERMOGRAPHY STATIONERY SET

FOIL STAMPING SAMPLES

EMBOSSING REQUEST QUOTATION

ENGRAVING TIPS & POINTERS

LOG IN AS GUEST CONTEST REGISTRATION E-MAIL

PRINTING PROCESS

	PRICE/10,000	PRICE/SHEET
LITHO ONE COLOR	$722.00	$.07
LITHO TWO COLORS	$847.00	$.08
ENGRAVE ONE COLOR	$933.00	$.09
ENGRAVE TWO COLORS	$1,318.00	$.13
LITHO ONE COLOR AND FOIL STAMP	$1,262.00	$.13
LITHO TWO COLORS AND FOIL STAMP	$1,382.00	$.14
LITHO ONE COLOR, FOIL AND EMBOSS	$1,832.00	$.18
LITHO TWO COLORS, FOIL AND EMBOSS	$1,929.00	$.19

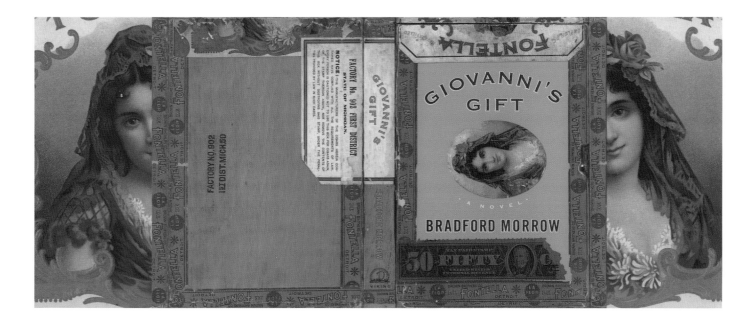

"GIOVANNI'S GIFT" COVER

ART DIRECTOR/DESIGNER: Paul Buckley

STUDIO: Penguin USA, New York, NY

CLIENT/SERVICE: Penguin USA/book publishing

TYPEFACES USED: Copperplate, Trade Gothic

SOFTWARE: QuarkXPress, Adobe Illustrator, Adobe Photoshop

COLORS: Four, process, plus two, match

PRINT RUN: 30,000

CONCEPT: For this book cover design for the novel *Giovanni's Gift*, "a cigar box is a key element in this mystery," says Paul Buckley. "It holds many of the clues to the questions that are raised in this story. The reader opens the book the same way the main character opens the box—both for the story contained within." This approach finally satisfied even the author himself, who "micromanaged [the process] every bloody step of the way."

SPECIAL PRODUCTION TECHNIQUES: Multiple scans created the illusion of a box; extensive color correction ensured a suitably weathered look.

ART DIRECTORS/DESIGNERS: James Strange, Sonia Greteman

STUDIO: Greteman Group, Wichita, KS

CLIENT/SERVICE: Kansas Elks Training Center for the Handicapped (KETCH)/training center for the handicapped

PHOTOGRAPHER: Linda Robinson

TYPEFACES USED: Avant Garde, Trixie

TYPE DESIGNER: Erik van Blokland (Trixie)

SOFTWARE: Macromedia FreeHand

COLORS: Four, black and match

PRINT RUN: 5,000

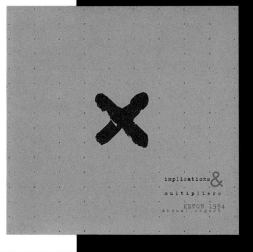

CONCEPT: "The annual report connects the training center's yearly financials with the human element," says designer Sonia Greteman. "It evokes emotion by telling specific stories rather than simply relaying statistics and generalities. A simple, yet graphic, photo boldly reinforces the key message of each person featured; torn photos placed at various angles and locations on the page mirror the off-balance, haphazard nature of life when handicapped. Sans serif numbers convey the hard data in a clean, straightforward manner." This concept worked for the client because "it portrays the true purpose of KETCH. It shows the human side, as well as the financials. The annual report serves as an invaluable fundraising tool. It justifies the center's mission and its worthiness of donors' support."

INSPIRATION: "The personal stories of the handicapped people who have had their lives enriched by KETCH."

SPECIAL PRODUCTION TECHNIQUES: The torn photos were scanned and reversed in FreeHand.

SPECIAL COST-CUTTING TECHNIQUES: All photography was condensed into a one-day shoot, everyday objects were used as photo props and a man on the street was used as a model.

ART DIRECTOR: Scott Greer

DESIGNER: Wade Palmer

STUDIO: University of Utah Graphic Design, Salt Lake City, UT

CLIENT: Ballet West Conservatory

PHOTOGRAPHER: Mikel Covey

TYPEFACES USED: Bodoni (headlines, headings, blurred copy), Gill Sans (subheads, text copy)

SOFTWARE: QuarkXPress, Adobe Photoshop, Adobe Illustrator

COLORS: Four, match

PRINT RUN: 1,000 (brochure); 250 (poster)

COST PER UNIT: $3.50 (brochure); $4 (poster)

CONCEPT: Designer Wade Palmer describes this brochure and poster for the Ballet West Conservatory as "sophisticated and minimalistic." He describes the design of the piece as an attempt "to steer away from the all-too-common soft *flower motif* and into a more masculine, cutting-edge, dynamic feel. Its emotionally compelling graphic personality communicated the essence of ballet dance."

INSPIRATION: The design was inspired by a combination of things, according to Palmer: "The dynamic motion of the ballet dancers, the clean and sophisticated feel of black-and-white silhouette photography, the energy of dance and cutting-edge photography."

SPECIAL PRODUCTION TECHNIQUES: Blurred type using Photoshop filters; varnish coating on photography; silhouette of photography shot against white background and then carefully "cut out" in Photoshop.

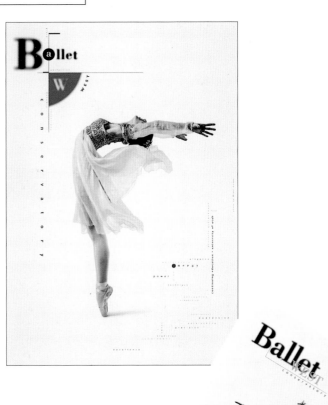

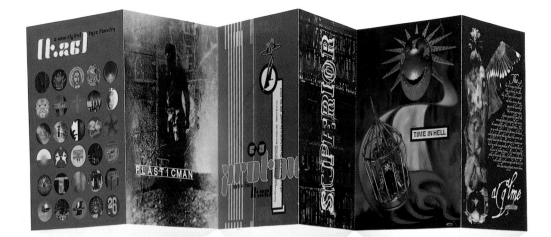

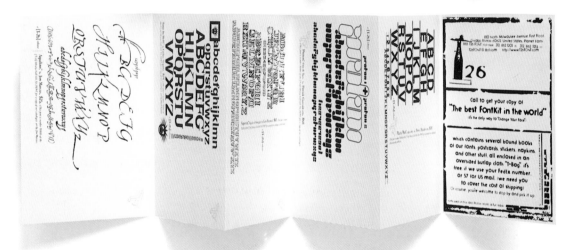

[T-26] ACCORDION POSTCARDS

ART DIRECTOR/DESIGNER: Carlos Segura

STUDIO: Segura, Inc., Chicago, IL

CLIENT: [T-26] Type Foundry

ILLUSTRATORS: Mark Rattin, Jim Marcus, Hatch, Carlos Segura, John Ritter, Tony Klassen, Laura Alberts, Colin Metcalf, Greg Heck

TYPEFACES USED: Proton, Plasticman, Superior, Time in Hell, Aquiline, Fur

TYPE DESIGNERS: Patrick Giasson (Proton), Denis Dulude (Plasticman), Gary Hustwitt (Superior), Carlos Segura (Time in Hell), Jim Marcus (Aquiline), Paul Sahre (Fur)

SOFTWARE: QuarkXPress, Adobe Photoshop, Adobe Illustrator, Ray Dream Designer

COLORS: Four, process

PRINT RUN: 10,000

CONCEPT: The goal of this set of postcards for the [T-26] Type Foundry was to have each panel capture the meaning and tone of the font it promoted in a way that varied from card to card and yet cohered as a whole.

ART DIRECTOR: Bill Cahan

DESIGNER/ILLUSTRATOR: Bob Dinetz

STUDIO: Cahan and Associates, San Francisco, CA

CLIENT: Western Art Directors Club

PHOTOGRAPHER: Quantity Postcards, David Robin

TYPEFACES USED: Caslon, Trade Gothic Heavy

SOFTWARE: QuarkXPress, Adobe Illustrator

COLORS: Four, process

CONCEPT: "The intention behind this poster," says Bill Cahan, "was to create attention and increase the number of entries for the awards show. The unique regional scope of the show was emphasized by using postcard imagery to represent each of the areas."

ART DIRECTOR/DESIGNER/ILLUSTRATOR: Martin Ogolter

STUDIO: Y Design, New York, NY

CLIENT/PRODUCT: Lincoln/music

TYPEFACES USED: Verdana, Balance

TYPE DESIGNERS: Matthew Carter (Verdana), Evert Bloemsma (Balance)

SOFTWARE: Adobe Photoshop, Adobe Illustrator

COLORS: Four, process

CONCEPT: "The lyrics of Lincoln are twisted, metaphorical and full of clichés taken out of context," says Martin Ogolter of the client for whom he designed this poster. Explaining the imagery he chose for the piece, Ogolter says, "The background, a Tibetan Thangka painting of the god of crazy wisdom, is superimposed over a crying devil and a type illustration of the word *Lincoln* over and over." The repetition of the word makes sense because "the band leader's favorite subject is himself and his music." Ogolter adds, "Though the devil has nothing to do with Tibetan painting, he fits perfectly in the background, mostly because of the fire halo."

ART DIRECTOR/DESIGNER: Neal Ashby

STUDIO: Recording Industry Association of America (RIAA), Washington, DC

CLIENT/SERVICE: Recording Industry Association of America

ILLUSTRATOR: John Moore

PHOTOGRAPHER: Amy Guip

TYPEFACES USED: Graffiti, Bell Gothic

WRITERS: Fred Guthrie, Neal Ashby

SOFTWARE: QuarkXPress, Adobe Illustrator, Adobe Photoshop

COLORS: Four, process

PRINT RUN: 5,000

COST PER UNIT: $5

CONCEPT: "As in any annual report, we wanted to examine the year that had just passed," says the Recording Industry Association of America's Neal Ashby. "But the RIAA also wanted to focus on where we were going in the coming year. The cassette player terms *rewind/fast forward* seemed just right." To help communicate that concept, Ashby hired Amy Guip, a New York photo-illustrator, to create the annual report's images. "It took me three years to convince the executives at RIAA that Amy Guip's photography wouldn't be too macabre for our annual report," says Ashby. "When the photography was finished, I thought Amy's work struck just the right tone, particularly on some of our emotional issues, like censorship. To maintain the texture of Amy's work on pages where there were no images, color-test prints from Amy's studio were used as backgrounds."

SPECIAL TYPE TECHNIQUES: Ashby occasionally customized Bell Gothic (used in this piece for large words and headlines) by adding or subtracting a serif off of the face. To do this, he pulled a word into Adobe Illustrator, created outlines of the word and adjusted it; he then saved it as an EPS and brought it back into Quark.

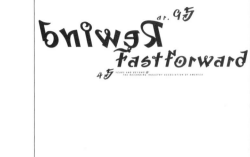

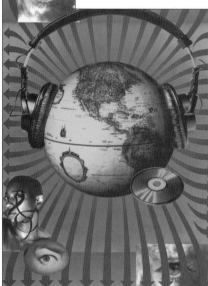

FIRST THINGS FIRST 21

Not a year goes by without at least one state legislature undertaking a serious effort to restrict free speech. That none of them has succeeded can be attributed to three powerful influences: the good sense of the American people, the good citizenship of the recording industry and its Parental Advisory Program, and the tireless efforts of the RIAA — we respond.

EDUCATION IS THE BEST CHOICE

The Parental Advisory Program is arguably our industry's most important contribution to free speech, for in countless cases it has helped preserve free speech. By voluntarily creating and administering this program, U.S. record companies have acknowledged their responsibility to help parents set and enforce standards for their children, without imposing those standards on others. In 1995, the RIAA and the National Association of Recording Merchandisers (NARM) strengthened the program, encouraging more consistent use and placement of the logo, both on the packaging of recorded music and in promotional and advertising materials. In addition, the RIAA has revised the logo so that it applies to both audio and music video product, and has inaugurated a campaign to foster greater media coverage of the logo and its use.

SOMETIMES THERE IS NO CHOICE

When a censorship law is proposed, the RIAA responds with an education campaign to inform legislators about the Parental Advisory Program. (Many proposed laws actually single out recordings that carry the logo.

Last year, all three elements came into play.

In Louisiana, Rep. Ted Haik kept alive his biennial tradition of introducing legislation to criminalize the sale of sound recordings bearing the Parental Advisory logo. In three previous attempts, Rep. Haik's bills have been enacted by the legislature, only to be vetoed by two different governors. This year, his bill failed to clear committee after a hearing filled with librarians, parents, record store workers and music distributors, and his attempts to run the bill through the full Senate also failed.

In Pennsylvania, a bill to criminalize the sale of labeled sound recordings was voted out of the House Judiciary Committee in early 1995 (the full legislature failed to enact a similar bill in 1994). After forceful negotiations with representatives of the RIAA and NARM, the bill's sponsor agreed to table it until the full session, beginning last September. At this writing, the bill is still in committee.

In Washington state, a bill had already been enacted that dealt with an array of materials deemed "harmful to minors" — the bill included sound recordings despite the RIAA's efforts to have them removed. Subsequently, we shifted our focus to Governor Mike Lowry's office, working in conjunction with the Washington Music Industry Coalition. Our joint efforts were rewarded by the governor's veto, which survived an override attempt in May.

ANTI-PIRACY

Back to our Future

THE RIAA HELPS SHAPE THE TECHNOLOGIES THAT WILL DRIVE OUR BUSINESS INTO A NEW ERA

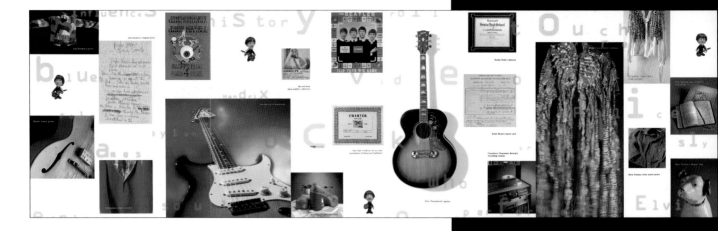

ROCK AND ROLL HALL OF FAME AND MUSEUM BROCHURE

ART DIRECTORS: Mark Schwartz, Joyce Nesnadny

DESIGNERS: Joyce Nesnadny, Brian Lavy, Michelle Moehler, Mark Schwartz

STUDIO: Nesnadny + Schwartz, Cleveland, OH

CLIENT: Rock and Roll Hall of Fame and Museum

PHOTOGRAPHER: Tony Festa (collection), various (people and events)

TYPEFACES USED: OCR (headlines), Century (text)

SOFTWARE: QuarkXPress, Adobe Photoshop

COLORS: Seven-over-four, process, varnish and metallics (cover); nine-over-nine, process, varnish and metallics (interior)

PRINT RUN: 7,000

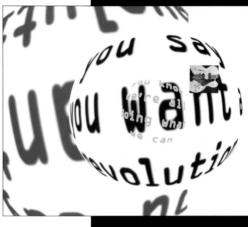

CONCEPT: In designing this piece, Nesnadny + Schwartz's goal was "to design a brochure that communicated the significance of the Rock and Roll Hall of Fame and Museum to potential donors and supporters in the music industry," says Mark Schwartz. "The Museum's goal is to recognize and explore the impact of those who have contributed significantly to the history of rock and roll." To communicate this, "our solution was to design a piece which presented itself in a somewhat unconventional format," says Schwartz. "Photographs of the inductees, various memorabilia and artifacts were used liberally throughout the brochure; this enabled us to provide a colorful, lively and visually engaging piece that was inviting, compelling and fact-filled."

SPECIAL PRODUCTION TECHNIQUES: The front cover was printed in three passes: The first pass was four-color process plus a metallic copper, the second was gloss spot varnish and the third was dull spot varnish. Text was printed in two passes, with the first pass consisting of four-color process plus a metallic green and the second of black, red, metallic green and gloss spot varnish. All metallic type was manipulated in Photoshop and printed as either a 45 percent screen or as 100 percent of metallic copper or green.

ART DIRECTOR/DESIGNER: Thomas Wolfe

STUDIO: Kerosene Halo, Chicago, IL

CLIENT: Tooth & Nail Records

PHOTOGRAPHERS: Thomas Wolfe (stills), Norman Jean Roy (band photography)

TYPEFACES USED: Meta, Univers, Matrix Script

TYPE DESIGNERS: Erik Spiekermann (Meta), Zuzana Licko (Matrix Script)

SOFTWARE: Adobe Illustrator, Adobe Photoshop, QuarkXPress

COLORS: Four, process

PRINT RUN: 10,000-15,000

CONCEPT: "When our client approached us with this project," says Thomas Wolfe, "they had already acquired photography of the band that was bold, yet held a childlike innocence. We felt that the entire package should follow in this direction, so we decided to take an item from our childhood (Hot Wheels cars) and make it larger than life to exaggerate the playful qualities of the band. When photographing these stills, we chose our color palette, simple sweeps of vibrant colors that would heighten the effect.

"In addition to keeping the imagery for the album and the single consistent, we also made reference to another childhood memory, a record's playing speed (45s and 33s). We labeled the album with the number *33* very subtly (and at times not so subtly) throughout the package, and then for the single we replaced these references with the number *45*. We felt this would lend itself to the concept behind the art and also tie the products tightly together."

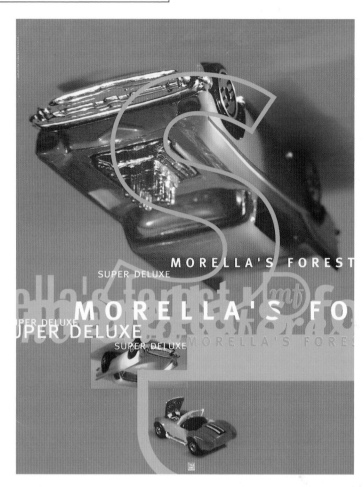

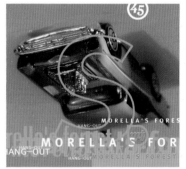

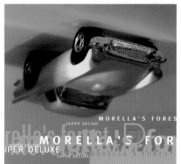

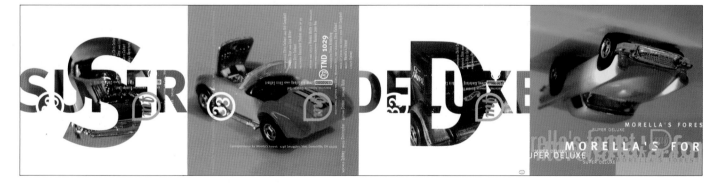

ART DIRECTOR: Paul Wharton

DESIGNER: Tom Riddle

STUDIO: Little & Company, Minneapolis, MN

CLIENT: Fraser Papers Inc.

PHOTOGRAPHERS: Michael Crouser, Rodney Smith

TYPEFACES USED: Benbo, Univers Condensed, Letter Gothic, Kuestler Script

SOFTWARE: QuarkXPress, Adobe Photoshop, Adobe Illustrator

COLORS: Six, match and process

PRINT RUN: 75,000

COST PER UNIT: $0.25

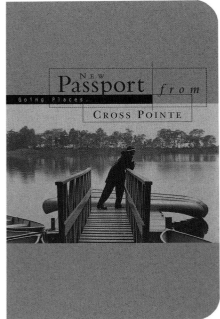

CONCEPT: According to Amy Dillahunt of Little & Company, this promotion for Fraser Papers' new line of paper, Passport, worked for them because "it told their clients in a few words the beauty and printability of the newly released paper product. It also very straightforwardly explained why designers should and would be interested in the line."

INSPIRATION: "The visual concept was built around fashion advertising," says Dillahunt. "We wanted to use photography to give a sense of romance and style. The line's new color palette was the key inspiration. The name 'Passport' indicated the size and shape."

SPECIAL PRODUCTION TECHNIQUES: "The use of several opaque inks, several duotones with both match colors and process colors, tritones and quadtones, fake duotones and comparison to standard four-color process separations."

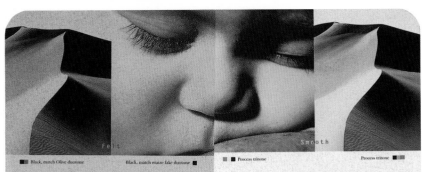

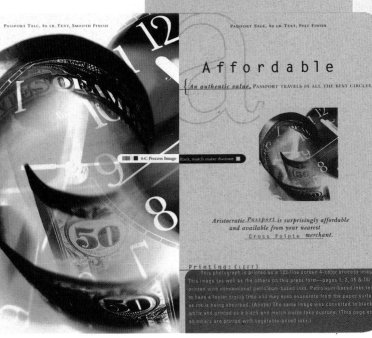

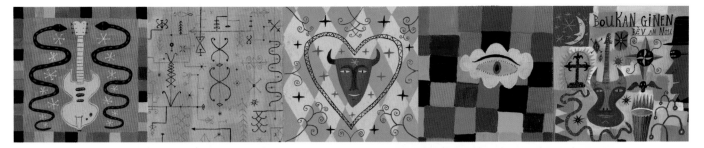

BOUKAN GINEN "RÈV AN NOU" CD

ART DIRECTORS/DESIGNERS: Karen L. Greenberg,
D. Mark Kingsley

STUDIO: Greenberg Kingsley, New York, NY

CLIENT/PRODUCT: Xenophile Records

ILLUSTRATOR: Calef Brown

TYPEFACES USED: Bell Gothic, Trade Gothic, hand-lettering

HAND-LETTERER: Calef Brown

SOFTWARE: QuarkXPress, Adobe Photoshop

COLORS: Four, process

CONCEPT: This colorfully illustrated CD packaging for a Haitian music group "is very representational of Haitian artwork," says Karen L. Greenberg. She adds that "the record company loved the package, but the band felt it was too primitive. Based on the target audience (white, affluent Americans) and the increasing interest in primitive folk art, the package served the client's need."

INSPIRATION: "The artwork was inspired by Haitian voodoo iconography, in which symbols are drawn as doorways into the spirit world and as cosmological maps," says Greenberg.

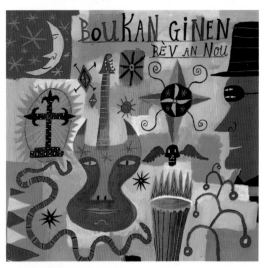

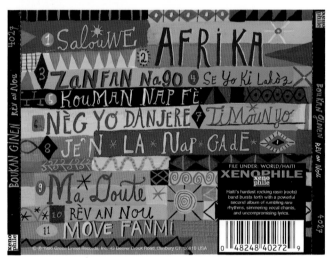

ART DIRECTOR: Stephanie Redman

DESIGNERS: Stephanie Redman, Lisa Ballard, Dan Pessell

CONCEPT/CONTENT: Kathleen Reinmann, Lycette Nelson, Ann Weber, Lisa Baggerman

STUDIOS: F&W Publications, Siebert Design Associates, and Zender and Associates, Cincinnati, OH

CLIENT/PRODUCT: *HOW Magazine* and F&W Publications/graphic design magazine

ILLUSTRATORS: Lisa Ballard, Dan Pessell

ANIMATOR: Dan Pessell

SOFTWARE: Adobe Photoshop, Adobe Illustrator, GIF Animator

CONCEPT: The overall concept for *HOW Magazine*'s Web site (located at http://www.howdesign.com) was to produce a high-energy, fun-to-browse site that complemented the featured business and technology content. "It was very much a collaborative effort," according to Stephanie Redman. "The in-house art department, with Zender and Associates' advice, designed the grid, look and flow of the site, using a newer frames technology. Once the basic grid and logic tree was established, Siebert Design Associates came on board to provide further design suggestions and establish the illustrative look of the site. Interestingly enough, the in-house art department was able to pick up this style on more illustrations, and all illustrations were animated in house." Illustrations for each of the sections are animated: For instance, the shopping cart in the "Stuff to Order" section continually rolls across the frame to the left, and the anthropomorphic briefcase in the "Business Bytes" section continually bites, as suggested by the section's title.

DESIGNER: Neil Carter

STUDIO: Eg.G, Sheffield, England

CLIENT/SERVICE: The Republic/nightclub

TYPEFACES USED: Univers, Compacta, Buppo

SOFTWARE: Adobe Illustrator, Adobe Photoshop

COLORS: Four, process

PRINT RUN: 20,000

COST PER UNIT: £0.08

CONCEPT: Dom Raban of Eg.G says that the client that commissioned these fliers, a nightclub, "requested that the design have an international feel to reflect the diverse nationalities of DJs playing at the club," as well as to reflect the club's international theme, which changes monthly, ranging from French toast to English football.

SPECIAL PRODUCTION TECHNIQUES: Manipulation of the images required extensive use of channels in Photoshop.

ART DIRECTOR/DESIGNER: Tom DeMay, Jr.

CLIENT: *Internet Underground* magazine

ILLUSTRATOR: Greg Spalenka (prisoner), Tom DeMay, Jr. (BCGD)

TYPEFACES USED: Flattop (headings), Procession (byline), Franklin Gothic (deck/body)

TYPE DESIGNERS: Craig Steen (Flattop), Sharon Marson (Procession)

SOFTWARE: QuarkXPress, Adobe Photoshop

COLORS: Four, process

CONCEPT: "I was trying to create a dark, barren, isolated place for the viewer to enter—something reminiscent of the cell in which the condemned man was in," Tom DeMay, Jr., says of this design for an *Internet Underground* feature. "Greg Spalenka's style fit the mold nicely, so he was chosen to create the art. The overprinting of handwriting on the background and illustration created a more cohesive whole."

INSPIRATION: "Mostly observing a lot of the urban decay around Chicago."

Does this Dispatches from Death Row prisoner's freedom of speech violate his dead victims' rights?

by Steve Knopper

art by Greg Spalenka

Dean has no friends.

Alex Bennett says he put up his page to "humanize" death-row inmates.

Life behind bars: Dean Carter (left) chronicles his death row life at Dead Man Talkin'

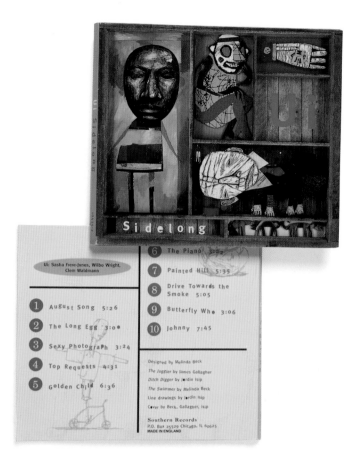

UI "SIDELONG" CD

ART DIRECTOR/DESIGNER: Melinda Beck

STUDIO: Melinda Beck Studio, New York City, NY

CLIENTS: Ui, Southern Records

ILLUSTRATORS: Melinda Beck, James Gallagher, Jordin Isip

PHOTOGRAPHER: Paul Kaufman, Raffi/Van Chromes, Inc.

TYPEFACES USED: Meta

TYPE DESIGNER: Erik Spiekermann (Meta)

SOFTWARE: QuarkXPress, Adobe Illustrator, Adobe Photoshop

COLORS: Four, process

PRINT RUN: 1,000

CONCEPT: The CD packaging features the work of three different illustrators—work the client wanted to be featured on the CD packaging; the digitally altered typography has the look of being pasted up by hand, a look inspired by the illustrations.

CAR FIRE SELF-PROMOTIONAL AD

ART DIRECTOR/DESIGNER: Thomas Scott

STUDIO: Eye Noise, Orlando, FL

CLIENT/SERVICE: Eye Noise/graphic design

PHOTOGRAPHER: John Petrey

TYPEFACES USED: Akzidenz Grotesk, Caslon 3 (headline); Egyptian (subhead, address); Franklin Gothic Condensed (address)

SOFTWARE: Adobe Illustrator, Adobe Photoshop

COLORS: Four, process

PRINT RUN: 10,000

CONCEPT: Of his design firm's *Alternative Pick* self-promotional ad, Thomas Scott says, "Many of the advertisers (other design firms) in this publication have dense, layered, very Macintosh-influenced pages. I wanted to stand out from the pack with a lot of white space and use a single, strong design element. My design philosophy is to create work that is indistinguishable as to whether it was created on a computer or conventionally with mechanical art. I am not interested in creating work that uses the latest software tricks. My primary goal is to have a well-executed concept. The headline and photo are a humorous (I hope) anti-technology statement that expounds my company philosophy."

SPECIAL PRODUCTION TECHNIQUES: Scott spent many hours retouching the photo of the floppy disk.

SPECIAL COST-CUTTING TECHNIQUES: Scott traded out his services with the photographer.

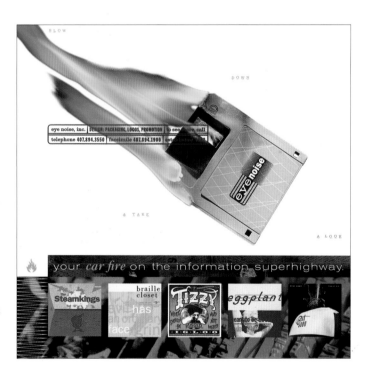

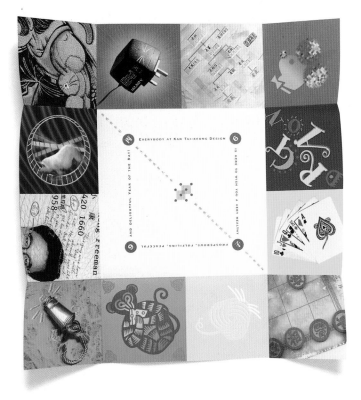

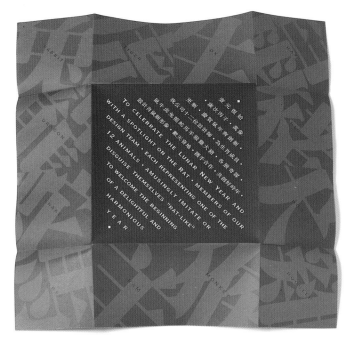

LUNAR NEW YEAR CARD

ART DIRECTORS: Kan Tai-keung, Freeman Lau Siu Hong, Eddy Yu Chi Kong

DESIGNERS: Kan Tai-keung, Freeman Lau Siu Hong, Eddy Yu Chi Kong, Benson Kwun Tin Yau, Joyce Ho Ngai Sing, Veronica Cheung Lai Sheung, James Leung Wai Mo, Man Lee Chi Man, Pamela Lau Pui Hang, Patrick Fung Kai Bong

STUDIO: Kan & Lau Design Consultants, Hong Kong

CLIENT: Kan & Lau Design Consultants

COLORS: Four, process

CONCEPT: In honor of the Lunar New Year and the Year of the Rat, all the designers in the studio got a chance to illustrate one of the twelve animals of the Chinese Zodiac disguising itself as a rat.

ART DIRECTOR: Dom Raban

DESIGNERS: Dom Raban, Neil Carter

STUDIO: Eg.G, Sheffield, England

CLIENT: Crucible Theatre/Danceworks

PHOTOGRAPHERS: Chris Nash, Hugo Glendinning, Richard Dean, Linda Molyneux

TYPEFACES USED: Trade Gothic, Helvetica, Univers, Vag Rounded, Berthold City

SOFTWARE: Adobe Photoshop, Adobe Illustrator, QuarkXPress

COLORS: Four, process

PRINT RUN: 40,000

COST PER UNIT: £0.25

CONCEPT: Inspiration for this brochure for a dance theatre "came from the performances each spread represents," says Dom Raban. "We were supplied with performance photographs, which were extensively modified and collaged in Photoshop to create a unity of type and image illustrative of each particular dance piece." This approach worked, he says, because "the experimental approach we took as designers complemented the experimental nature of the dance program."

ART DIRECTORS: Todd Houser, Mike Lopez

DESIGNERS: Todd Houser, Mike Lopez, Brian Stauffer

STUDIO: Pinkhaus, Miami, FL

CLIENT/SERVICE: Pinkhaus/design

ILLUSTRATORS: Todd Houser, Mike Lopez, Brian Stauffer

PHOTOGRAPHER: Todd Houser

TYPEFACES USED: Wunderlich

SOFTWARE: Adobe Illustrator, Adobe Photoshop

COLORS: Six-over-six plus varnish

PRINT RUN: 3,000

CONCEPT: These 3" × 3" self-promotion cards were "the opportunity to have a little fun," says designer Todd Houser. "We had room on a larger job, so we created these cards for self-promotion purposes. They are all personal, humorous little happy thoughts."

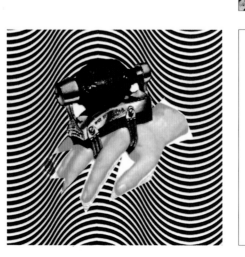

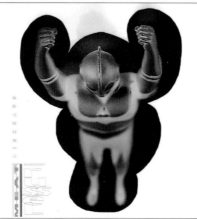

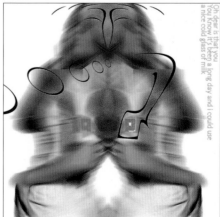

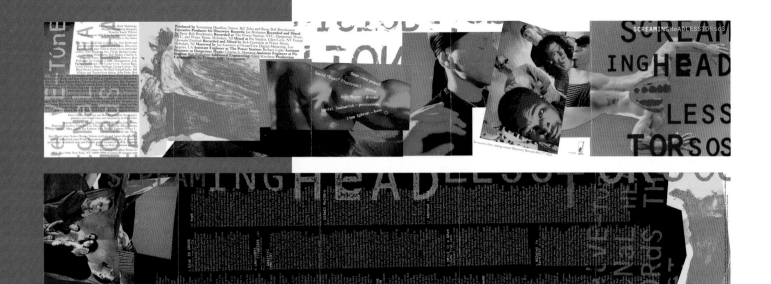

"SCREAMING HEADLESS TORSOS" CD

ART DIRECTORS/DESIGNERS: D. Mark Kingsley,
Karen L. Greenberg

STUDIO: Greenberg Kingsley, New York, NY

CLIENT/PRODUCT: Discovery Records

PHOTOGRAPHER: Mark Malabrigo

TYPEFACES USED: OCR-A, OCR-B, Janson

SOFTWARE: Adobe Photoshop

COLORS: Four, process

CONCEPT: "The name of the band gave us the front
cover," says Karen L. Greenberg of this CD design
for the group Screaming Headless Torsos.
"Everything else was inspired by the group's per-
formance style." Oversaturating the photographs
with color in Photoshop, and combining these
images with manipulated type, gives the piece the
"brash" look the designers wanted.

SPECIAL TYPE TECHNIQUES: "Front-cover type was
manipulated outside the computer, scanned back
in and further manipulated in Photoshop."

CONCEPT

TYPE

IMAGE

LAYOUT

Recipe for designs in this chapter: Take one concept, add some type and images, and then combine in a lay-out that goes beyond grids—or at least utilizes them creatively—to create something unexpected and attention-getting.

In this section you'll see:

• how Christina Maier of Neoglyphix managed to incorporate the names of every frog in the world in a lay-out for a short story where frogs were a central plot element.

• how Melinda Beck was inspired by pop art and supermarket-flier graphics to create a layout for a club's flier that used an image of a waffle as a centerpiece.

• how Kan & Lau Design Consultants designed an unusually shaped theater program inspired by the shape of the theater itself.

ART DIRECTOR: Antero Ferreira

DESIGNER: Sofia Assalino, Anna-Carin Skytt, Jorge Serra, Antero Ferreira

STUDIO: Antero Ferreira Design, Oporto, Portugal

CLIENT: Antero Ferreira Design

PHOTOGRAPHERS: Antero Ferreira Design, Oscar de Almeida

TYPEFACES USED: Trajan

SOFTWARE: Macromedia FreeHand, Adobe Photoshop

COLORS: Two, match

PRINT RUN: 500

CONCEPT: This newsletter promoting the services of Antero Ferreira Design "gives a real image and ambience of the studio: the graphics, the spirit, the people and the colors," says designer Antero Ferreira. The gatefold brochure overlays collaged photos with important news related to the studio.

SPECIAL PRODUCTION TECHNIQUES: The use of duotones, digital retouching and image collage gives this brochure its unique look.

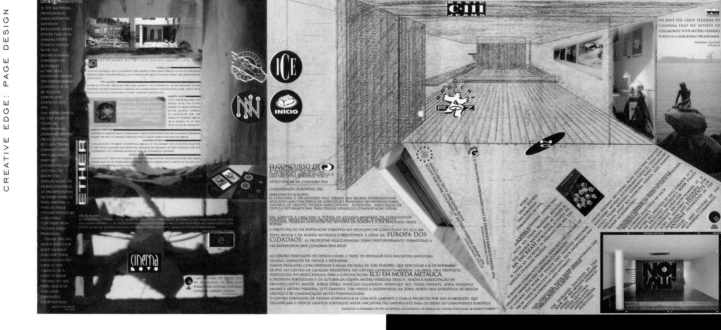

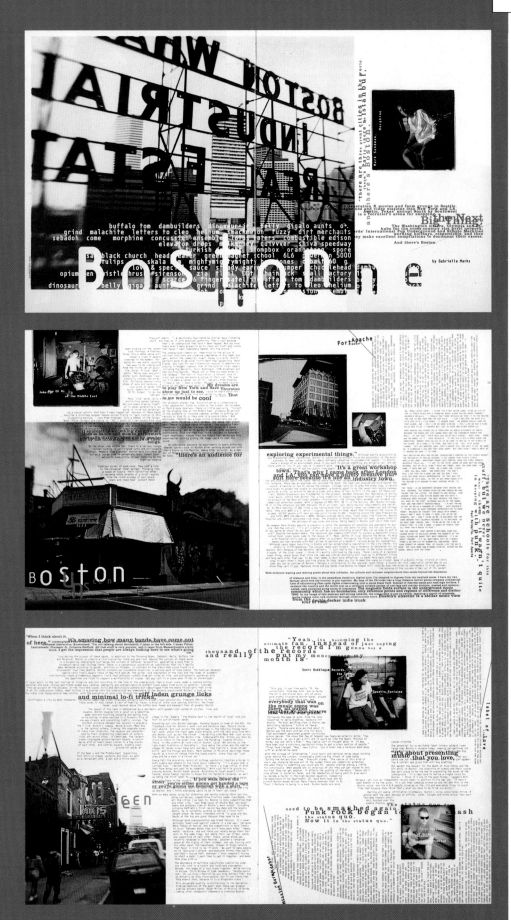

ART DIRECTOR/LOCATION: David Carson, Del Mar, CA

DESIGNERS/LOCATION: Clifford Stoltze, Peter Farrell/Boston, MA

CLIENT: *Raygun* magazine

PHOTOGRAPHER: Russ Quankenbush

TYPEFACES USED: Isonorm, Clarendon

SOFTWARE: QuarkXPress

COLORS: Four, process

CONCEPT: Clifford Stoltze comments that this design for an article about the Boston music scene in *Raygun* magazine worked for the client because "they didn't have to pay for it and they made our design credit illegible by moving it over a dark photo (the full extent of the art direction)."

INSPIRATION: "Our experiences going to nightclubs in Boston and the view out our studio window," says Stoltze.

SPECIAL PRODUCTION TECHNIQUES: "The individual sizing of each letter of every word in the pull quotes."

ART DIRECTOR: Kenzo Izutani

DESIGNERS: Kenzo Izutani, Aki Hirai

STUDIO: Kenzo Izutani Office Corporation, Tokyo, Japan

CLIENT/PRODUCT: Platinum Guild International/platinum promotion

STATUARY: Katsura Funakoshi

PHOTOGRAPHERS: Yasuyuki Amazutsumi, Zigen, Miyako Ishiuchi, Ichigo Sugawara

COLORS: Four, process

CONCEPT: This magazine, a promotional vehicle for platinum, uses artistic images and lavish production (including an oversized format and high-quality paper stock) as a way to do some soft-sell promotion to its high-end client base.

ART DIRECTOR/STUDIO/LOCATION:
Joshua Berger/Plazm
Media/Portland, OR

DESIGNER/STUDIO/LOCATION: Christina
Maier/Neoglyphix/Portland, OR

CLIENT/PRODUCT: Plazm Media/magazine, digital type foundry, design
group

TYPEFACES USED: Cochin

SOFTWARE: Adobe Illustrator,
QuarkXPress

COLORS: One, black

PRINT RUN: 4,500

CONCEPT: "In this story, the protagonist
orgasmed at the mere mention of a
frog. She finally dies as a result of this
affliction," says designer Christina
Maier. "When I read the manuscript for this rather quirky story, I
was struck by the perfect symmetry of the story structure. I tried to
overcome the urge to use the obvious frog imagery. There was a very
pregnant pause after the sentence, 'Another fly in the ointment.' I
designed a visual climax at that editorial pause by placing a fly at the
vortex of the triangular text box—and avoided frogs altogether.

However, I did manage to include every frog in the world by
researching all of the scientific names and using them as a tiny typographic frame around the page."

SPECIAL PRODUCTION TECHNIQUES: "I used Adobe Illustrator to build
the angled text boxes and brought them into Quark, where the document was constructed."

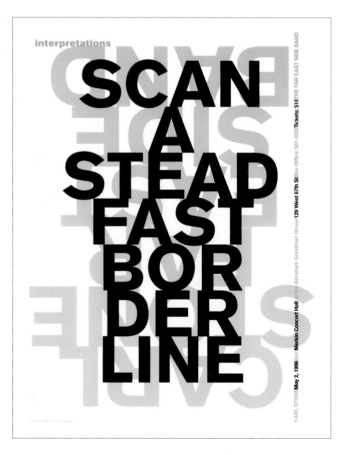

ART DIRECTORS/DESIGNERS: Karen L. Greenberg, D.
Mark Kingsley

STUDIO: Greenberg Kingsley, New York, NY

CLIENT/PRODUCT: Mutable Music/new music concert performance series

TYPEFACES USED: Franklin Gothic

SOFTWARE: Karma Manager, QuarkXPress, Adobe
Illustrator

COLORS: Two, match

PRINT RUN: 2,000

COST PER UNIT: $0.75

CONCEPT: "Both performers use sampling techniques: one with a computer and the other with
cultural references. We sampled their names with
an anagram program to come up with the headline," says Karen L. Greenberg of this invitation to
a new music concert.

DESIGNER: Rudy VanderLans

STUDIO: Emigre, Sacramento, CA

CLIENT/PRODUCT: Emigre/design trade magazine

TYPEFACES USED: Base 12 Serif, Base 9

TYPE DESIGNER: Zuzana Licko (Base 9 and Base 12)

SOFTWARE: Ready, Set, Go!, Fontographer

COLORS: Two, match

PRINT RUN: 7,000

CONCEPT: "To achieve as much as possible with as little as possible" is the concept and inspiration behind this cover design for *Emigre* #37, according to designer Rudy VanderLans. When asked why it worked for the client, VanderLans replies, "I am the client, and it was the best I could come up with—but since you guys picked it, it must have some other redeeming qualities as well."

Emigre 37

Price

$7.95

Joint Venture

Editor and designer: **Rudy VanderLans** |
Copy editor: **Alice Polesky** | Co-editor: **Anne Burdick** |
Emigre Fonts: **Zuzana Licko** | Sales, distribution, and administration: **Tim Starback** | Sales: **Frank Ortiz and Michael J. Kachmar** | Phone: **916.451.4344.** Fax: **916.451.4351** |
Email: **editor@emigre.com** |
Postmaster: Emigre (ISSN 1045-3717) is published quarterly for $28 per year by Emigre, Inc., 4475 D Street, Sacramento, CA 95819. U.S.A. | Second class postage paid at Sacramento, CA |
Postmaster please send address changes to: Emigre, 4475 D Street, Sacramento, CA 95819, U.S.A. | Copyright © 1996 Emigre Graphics | All rights reserved | No part of this publication may be reproduced without written permission from the contributors or Emigre Graphics |
Emigre is a registered trademark of Emigre Graphics |

Winter 1996

Inside front and inside back covers:
Nothing Special and *Something Special*
Framed illustrations by Marc Nagtzaam
shown at the Emigre Studio

ART DIRECTOR: Paul Wharton

DESIGNER: Tom Riddle

STUDIO: Little & Company, Minneapolis, MN

CLIENT: Fraser Papers Inc.

ILLUSTRATORS: John Hersey, Chuck Hermes, Josh Gosfield, Erik Adigard

PHOTOGRAPHER: Michael Crouser

TYPEFACES USED: Typewriter Regular, DIN Schriften Engschrift, Matrix Script, Kuenstler Script No. 2 Bold, Univers Condensed

TYPE DESIGNER: Zuzana Licko (Matrix Script)

SOFTWARE: QuarkXPress, Adobe Photoshop, Adobe Illustrator

COLORS: Four, process, plus two, match

PRINT RUN: 50,000

COST PER UNIT: $0.70

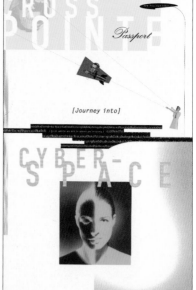

CONCEPT: "Passport paper was being upgraded. Fraser Papers wanted to reinforce Passport's quality and support the brand," Little & Company's Amy Dillahunt says was the purpose behind this paper promotion. "The theme of traveling the Internet supported the travel connotation of the brand name and demonstrated a link to both current design thinking and technology," she continues. "We wanted to reflect back the *free space* digital-info characteristics of the Internet. The text is placed by time notations into information *bites* with important tips or numbers highlighted as on a computer screen." This concept worked for the client because "it provided useful, current information and suggestions about Internet exploration to the intended audience—designers—while demonstrating their product's great printability."

INSPIRATION: "The electronic garble and eclectic nature of the Internet itself."

SPECIAL PRODUCTION TECHNIQUES: The piece used double fluorescent fake duotones, two solid metallic inks and fluorescent orange and black duotones.

NOVEMBER COOLER CALENDAR

ART DIRECTOR/DESIGNER/ILLUSTRATOR: Melinda Beck

STUDIO: Melinda Beck Studio, New York City, NY

CLIENT/SERVICE: The Cooler/nightclub featuring live music

TYPEFACES USED: Helvetica, Vagabond, Meta

TYPE DESIGNER: Erik Spiekermann (Meta)

SOFTWARE: QuarkXPress, Adobe Illustrator, Adobe Photoshop

COLORS: One, match

CONCEPT: This monthly calendar for a nightclub uses a found image of a waffle on one side and a calendar on the other side, laid out to emulate the waffle's shape, to catch the viewer's attention.

INSPIRATION: "Pop art and supermarket-circular graphics," says designer Melinda Beck.

SPECIAL PRODUCTION TECHNIQUES: "The visuals were created by taking images from food packaging and supermarket circulars and collaging them in Illustrator," says Beck.

CLIENT/PRODUCT: Microsoft Corporation, Inc./software, online publication

CREATIVE DIRECTOR/FIRM: Sunny Shender/Microsoft Corporation, Inc.

SENIOR PRODUCER: Renee Russak

SHOW PRODUCER: Emily Eldridge

PRODUCTION MANAGER: Brian Keffeler

ART DIRECTOR: Sunny Shender

FEATURES PRODUCERS: Kirsten Andrews, Sally Vilardi, Corrine Luesing

AUDIO PRODUCERS: Genevieve Buckley, Libby Landy

SCRIPTOR: Jacqueline Young

FEATURES EDITOR: Ann Fasano

TALENT PRODUCER: Beverly Kopf

DESIGNERS: Marion Hebert, Cari Wade

PRODUCTION DESIGN: Candy Knott

LOGO DESIGN AND VARIOUS DESIGN COMPONENTS: Margo Chase Design, Los Angeles, CA

ART DIRECTOR: Margo Chase

DESIGNERS: Margo Chase, Wendy Ferris Emery

TYPEFACES USED: Base 9 and Base 12, OCR-A, Missive, Matrix Script, Ecru

TYPE DESIGNERS: Zuzana Licko (Base 9, Base 12 and Matrix Script), Margo Chase (Ecru)

SOFTWARE: Adobe Photoshop, Adobe Illustrator

CONCEPT: This design for Microsoft's UnderWire Web site (located at http://www.underwire.msn.com) uses a clear layout and lots of striking photography to lead the reader through the site.

ART DIRECTOR: Clifford Stoltze

STUDIO: Stoltze Design, Boston, MA

CLIENT: Massachusetts College of Art

PHOTOGRAPHER: Various

TYPEFACES USED: Scala Sans and Serif, Calvino

SOFTWARE: QuarkXPress

COLORS: Four-over-four, process; two-over-two and one-over-one, match

PRINT RUN: 25,000

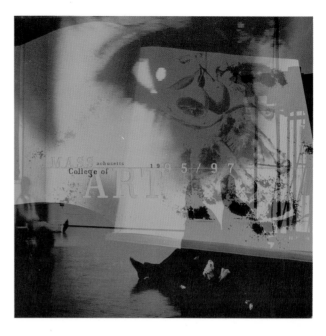

CONCEPT: For this catalog for an art school, "the intended audience is artistically inclined teenagers and twentysomethings," says Clifford Stoltze. This catalog uses layered typography and images and a trendy color palette to appeal to this audience.

INSPIRATION: "The diversity and energy of the school," says Stoltze.

SPECIAL PRODUCTION TECHNIQUES: This catalog's cover uses a Photoshop montage; halftones and duotones are used in various random combinations of spot colors.

SPECIAL COST-CUTTING TECHNIQUES: The 8 ¼"-square format fit twelve pages onto a half-web signature.

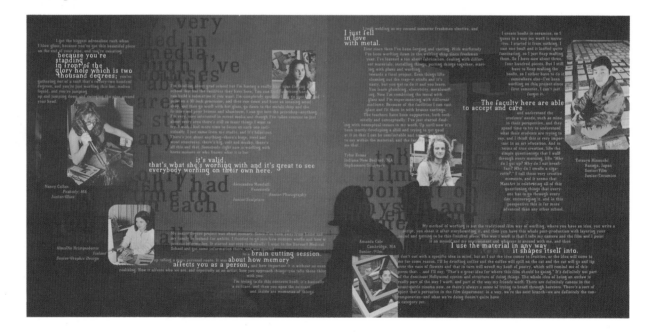

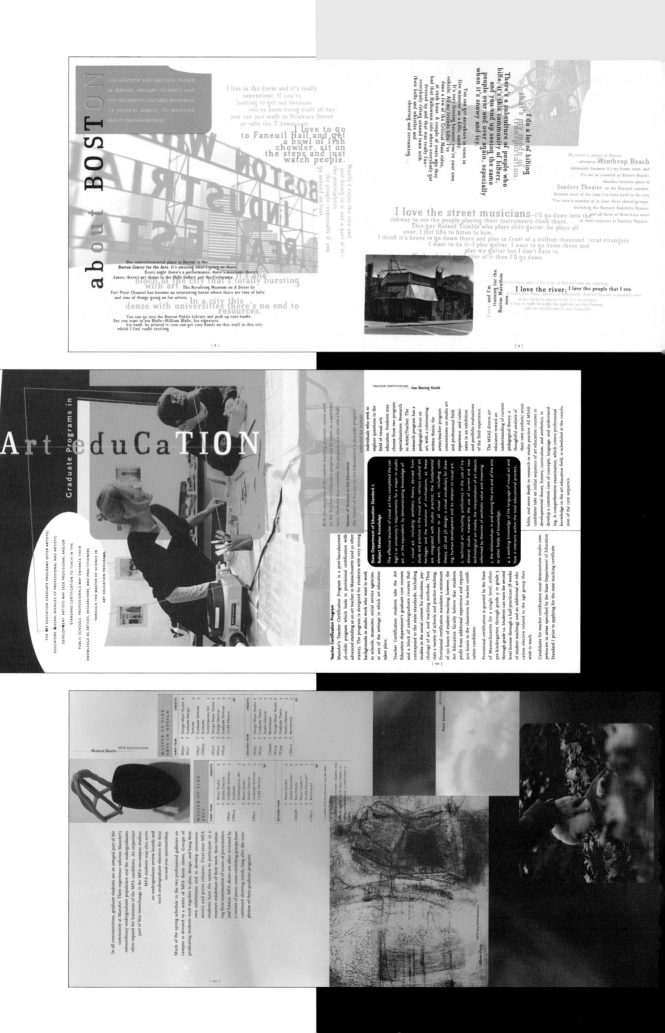

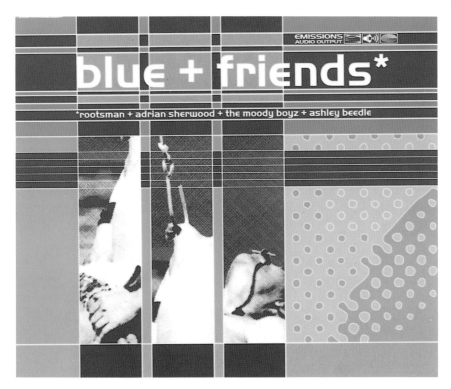

ART DIRECTOR/DESIGNER: Paul Nicholson

STUDIO: Prototype 21, London, England

CLIENT/SERVICE: Emissions Audio Output/record label

TYPEFACES USED: Handel Gothic Normal and Bold

SOFTWARE: CorelDRAW

COLORS: Two, match

CONCEPT: The client "wanted graphics to mirror the music—modern, abstract and new," says Paul Nicholson. "The low budgets of underground labels I work with usually dictate the format of the artwork—in this case, a standard CD-single sleeve and disc."

INSPIRATION: "Abstraction of formal typographic exercises as carried out by the Basel School of Typography."

"101+303+808 NOW FORM A BAND" CD

ART DIRECTOR/DESIGNER: Paul Nicholson

STUDIO: Prototype 21, London, England

CLIENT/PRODUCT: Sabres of Paradise/record label

TYPEFACES USED: OCR-A, Microgramma

SOFTWARE: CorelDRAW

COLORS: Four, match

CONCEPT: Paul Nicholson describes this CD design as "an amalgam of trashy elements of four decades—Warhol of the sixties, Punk of the seventies, cheap Japanese keyboards of the eighties (Roland 101, 303 & 808—basic instruments of techno-music) and nineties computer graphics. The resulting effect is chaotic and abrasive."

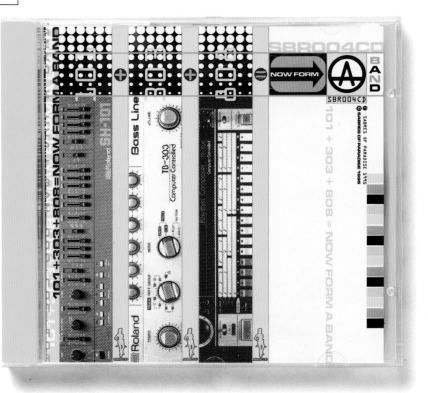

ART DIRECTOR/DESIGNER: Tadeusz Piechura

STUDIO: Atelier Tadeusz Piechura, Lodz, Poland

CLIENT/SERVICE: Galeria Manhattan/Ultraposter exhibition

TYPEFACES USED: Helvetica Bold Condensed, Helvetica Light, Helvetica Light Condensed

SOFTWARE: CorelDRAW

COLORS: One, black

PRINT RUN: 200

COST PER UNIT: $0.10

CONCEPT: This invitation was for an exhibition of an "Ultraposter" by designer Tadeusz Piechura. The Ultraposter consisted of two pieces that could be combined in a number of ways to create endless variations on a theme; the exhibition that this invitation was for displayed twenty different combinations. According to Piechura, "the invitation's format is the same as the poster's but reproduced on a smaller scale." The idea, he says, was that "all guests were able to discover their own perspective on the Ultraposter by folding and putting together the two pieces of their invitations."

SPECIAL COST-CUTTING TECHNIQUES: The invitation was laser-printed, and then cut by hand.

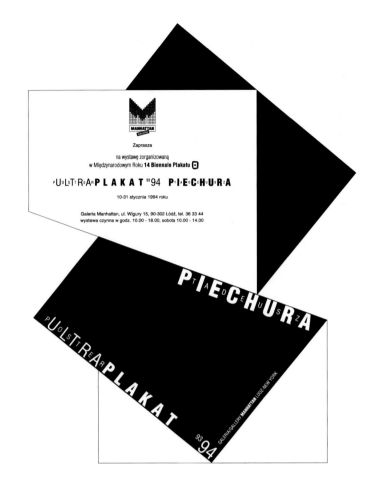

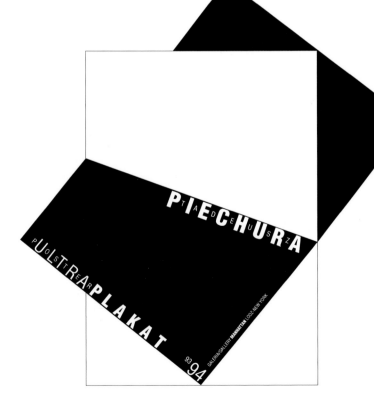

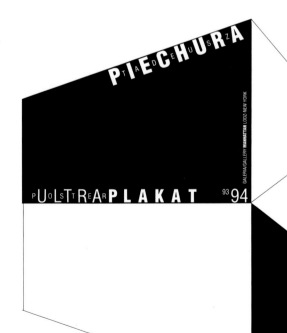

ART DIRECTOR: Paul Wharton

DESIGNER: Tom Riddle

STUDIO: Little & Company, Minneapolis, MN

CLIENT: Fraser Papers Inc.

ILLUSTRATOR: Ben Magnes

TYPEFACES USED: Officiana Sans Book

SOFTWARE: QuarkXPress, Adobe Photoshop

COLORS: Four, process plus varnish

PRINT RUN: 20,000

COST PER UNIT: $0.10

CONCEPT: For this piece, an announcement of a new Cross Pointe rep in the area, "We wanted to gain the attention of designers while providing a fun little paper sculpture to set on their desk," says Amy Dillahunt of Little & Company. "The announcement itself provided a visual theme of the Old West—'a new cowpoke in town.'" Dillahunt says this worked for the client because "it was easily noticed and memorable. Specification reps tracked phone response and found that they got a very high and positive response rate and that it created a ready conversation-starter when visiting for the first time."

SPECIAL PRODUCTION TECHNIQUES: "The die-cutting is the special feature that helps convert a simple message into a stand-up desk sculpture and reveals a fun illustration as you open it."

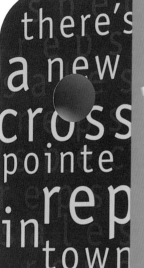

ART DIRECTORS: Carol Bobolts, Deb
Schuler

DESIGNERS: Carol Bobolts, Deb Schuler,
Adam Chris, Adria Robbin

STUDIO: Red Herring Design, New York,
NY

CLIENT: MTV Books/Pocket
Books/Melcher Media

PHOTOGRAPHER: Bettmann Archives, MTV
video grabs

TYPEFACES USED: Folio, Black Oak, Vintage
Typewriter, Felt Tip, Matrix Script Inline,
Helvetica, Bundesbahn Pi, Handwritten

SOFTWARE: QuarkXPress, Adobe
Photoshop, Adobe Illustrator

COLORS: Four, process

PRINT RUN: 250,000

CONCEPT: This design for a book document-
ing the "real" behind-the-scenes story of
MTV's semidocumentary "The Real World"
has an appropriately
scrapbook-like feel.

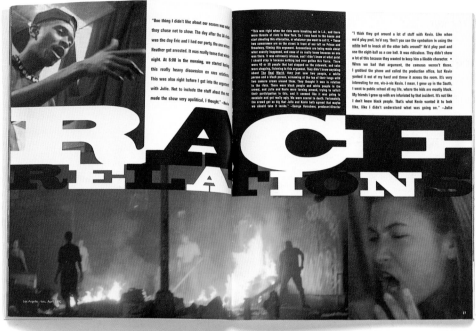

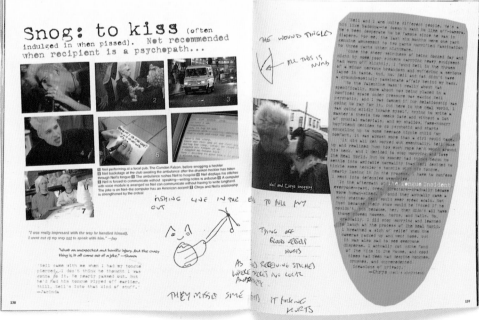

ART DIRECTOR/DESIGNER/ILLUSTRATOR/PHOTOGRAPHER: BBV Michael
Baviera, Zürich, Switzerland

CLIENT/PRODUCT: Poly Laupen/packaging

COLORS: Four, process

COST PER UNIT: CHF 5 (U.S. $3.50)

CONCEPT: As a result of the client's wish for a new identity, Michael
Baviera produced this unconventionally shaped brochure promot-
ing the client's packaging capabilities. The unusual layout—com-
pletely diagonally oriented, with text and four-color photographs
laid over ghosted photographs of the client's factory—gives the
brochure a unique and memorable look.

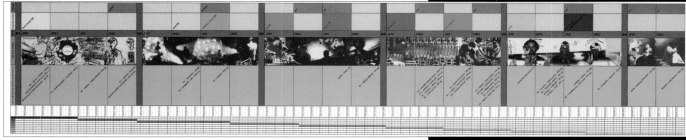

SALT TANK "SCIENCE AND NATURE ST7" CD

ART DIRECTOR/DESIGNER: Paul Nicholson

STUDIO: Prototype 21, London, England

CLIENT: Internal Records

TYPEFACES USED: Eurostile, Salt Tank

TYPE DESIGNER: Prototype 21 (Salt Tank)

SOFTWARE: CorelDRAW

COLORS: Four, process

CONCEPT: "The sleeve and album title are the continuation of a theme initiated with the Salt Tank logo," says Paul Nicholson. "The logo was designed in 1992 and is based on the Golden Section and ammonite fossils—hence the reference to 'Science and Nature.' The sleeve itself features a complex visual representation of time—that of the tracks and the history of the band's existence. As with all sleeves I design, continuity of layout from the front to the back through to the inner sleeves and labels is of paramount importance."

ART DIRECTORS: Joyce Nesnadny, Mark Schwartz

DESIGNERS: Joyce Nesnadny, Brian Lavy, Michelle Moehler

STUDIO: Nesnadny + Schwartz, Cleveland, OH

CLIENT/PRODUCT: Cleveland Institute of Art/art school

PHOTOGRAPHERS: Robert A. Muller, Mark Schwartz

TYPEFACES USED: Bodoni (headline), Meta (text)

TYPE DESIGNER: Erik Spiekermann (Meta)

SOFTWARE: QuarkXPress

COLORS: Six, match

PRINT RUN: 48,000

CONCEPT: "The Cleveland Institute of Art is an academic institution that provides education for men and women who seek professional art careers," says Mark Schwartz. "CIA offers a strong preprofessional foundation and a variety of art and design majors within its state-of-the-art facility. The catalog"—the fourth set of recruiting materials Nesnadny + Schwartz has produced for the school—"is the cornerstone of CIA's recruiting efforts. The audience consists primarily of high school students." To arouse interest in the school, to articulate the scope of the school's programs and to showcase the creative energy, challenge and excitement of a CIA education, "the catalog provides a colorful in-depth look at the school, interspersed with compelling images of activities at CIA and of student artwork." To ensure the catalog could stay up to date, all course descriptions and schedules are contained in a two-color addendum publication that is updated annually.

SPECIAL COST-CUTTING TECHNIQUES:

"The new catalogs were produced with dramatically different covers," says Schwartz. "By using the same 52 pages of content and changing the covers, we were able to realize an overall savings in our creative and production budgets of approximately 50 percent."

Facilities: Space, light, and time. Your working environment helps to shape your work and your attitude toward it. We strive to make all CIA facilities optimal for student artists. Our studios are on a par with professional studios. Most notable are the individual spaces assigned to each student working in a major—about 100-300 square feet per student, depending on the department. The studios are open for long hours so that you can work at your own pace. With a substantial studio space of your own, you gain a sense of control and input into your own development that can't be duplicated. About half of our major studios are located in the Gund Building, along with academic and foundation classrooms. Also in this building are the Gund Memorial Library, the most extensive art library in the state; 600-seat and 100-seat auditoriums; and the Reinberger Galleries, the second largest gallery in Cleveland and the site of important exhibitions

by noted outside artists, as well as shows by students, faculty, and alumni. Students can gather in the lounge/canteen in the Gund Building, and can frame their work in the wood shop downstairs. The rest of our studios are in the McCullough Center, a 1913 Ford Model T factory that's been renovated with windows on all sides and a 40-foot-long skylight, flooding the enormous studios with natural light. The high ceilings, wide corridors, and freight elevator allow students to work as large as they choose. A privately owned supply store is conveniently located on the first floor, as is the student coffeehouse, which offers exhibit space, reading areas, and performance space. On the third floor are a student-run gallery, student lounge, and 100-seat auditorium. Between our two buildings, you'll find plenty of space to work, learn, exhibit, view art, and just hang out.

o n

Student life: Did you say *Cleveland?* We appreciate a good joke as much as anyone, but we're glad to report that the latest news on Cleveland is more uplifting than funny. A building boom is transforming the face of downtown Cleveland, which now has an interesting mix of old and new architecture. The renewed lakefront offers sports activities and summer festivals. The Flats, once an industrial river valley below the downtown area, now presents an intriguing, offbeat contrast between light industry and waterfront entertainment, with dance clubs, concert venues, and restaurants. Just beyond the Flats are Tremont and Ohio City, historic neighborhoods with a growing alternative theater and club scene. In fact, many local artists draw inspiration from the proximity of these disparate elements — industry, nature, commerce, neighborhood life. Speaking of neighborhoods and inspirations, Cleveland's ethnic enclaves are slices of many cultures. African American, Asian, European, Latino, and Native American people have all made their own contributions to daily life here. University Circle. Your more immediate surroundings, in University Circle, combine campus life with culture. Just a few miles from downtown, University Circle is a single square mile that serves as home to dozens of cultural, educational, social, and medical institutions of regional and national importance. You'll find no shortage of artistic stimulation here. On campus. If you're an unmarried first-year student not living at home, you'll live on campus in Taplin House, between CIA's two buildings. Ongoing dorm activities, student lounges, special areas for art-related work, a kitchenette and a laundry make this a comfortable place to stay while you find your way around. In your own backyard, you can socialize at Friday night closings at the student gallery and openings in the Reinberger Galleries. The Cinematheque, CIA's film program housed in the Gund Building, shows avant-garde, foreign, and classic films Thursday through Sunday. Off campus. For visual art beyond CIA's own

resources, you have the Cleveland Museum of Art, one of the few world-class museums that doesn't charge an admission fee, across the street from CIA. Within a mile is the Cleveland Center for Contemporary Art, which presents important, often provocative exhibits and speakers. Just beyond the McCullough Center is the Murray Hill gallery district, where you can view crafts and fine art by local artists and from around the country. Classical music can be heard a block from CIA at Severance Hall, the home of the renowned Cleveland Orchestra, considered by many experts to be the best in the country; and at the Cleveland Institute of Music, a noted conservatory that stages frequent public programs. Students can attend music, dance, and opera performances at Severance Hall or at downtown auditoriums, using free tickets funded by the Kulas Foundation. Nature and science are close at hand in the form of the Cleveland Museum of Natural History, the Garden Center, and the Crawford Auto and Aviation Museum. Case Western Reserve University, a campus of about 9,000 students, generates a more traditional campus atmosphere and offers access to libraries, sports, a student union, a second-run film program, and an alternative radio station. Theater is easy to find, too. The nearby Cleveland Playhouse and the downtown Playhouse Square theaters feature mainstream plays, often with actors of national renown. Karamu House carries on a proud tradition as the nation's oldest African American center for theater, music, dance, and visual art. Smaller professional theaters throughout the city present innovative programming. The land beyond. When you need to stretch out, though, you'll find long stretches of countryside on every side of greater Cleveland, including the extensive Metroparks, historic small towns, Amish communities, rolling forest land, lakeside resort towns, and beaches. It's only a short drive from the densest neighborhoods to wide-open spaces.

f

C e r a m i c s

Every student does something different. We don't have proteges, and there's no CIA *look.* Classes change each year, depending on who's taking them. We encourage students to use the information we present in their own ways. Bill Brouillard

To be a good ceramist, you have to understand new-dimensional concerns and express them in tactile ways, in three-dimensional form. For example, drawing students can use their own information on clay instead of paper. Most students have more knowledge than they realize. Undiscovered resources abound, and they should be explored and considered. Realize what you know and use it. Judith Salomon

Ceramics. The ceramics department blends the contemporary and historical, collaborative and individual, two-dimensional and three-dimensional. Accordingly, ceramics students at CIA become well-rounded artists working in diverse styles. Early in the ceramics major, students concentrate on the vessel and pottery. They work with the full range of materials and learn traditional techniques of throwing, handbuilding, clay and glaze chemistry, and firing of gas and electric kilns. Later, they broaden their conceptual focus, refine their techniques, and adapt both to express their growing self-awareness. By sharing ideas, personalizing their sources, taking risks, and learning to criticize, they find their own voices. During their final year, students concentrate on their individual needs and build a cohesive body of work. Our exceptional facilities become especially valuable at this point: plenty of individual studio space, a 40-foot-long skylight, five student-constructed gas-fired kilns, many electric kilns, a separate glazing room. Advanced students also learn how they will work alone, set up their own studios, and compete in the marketplace. Some go on to graduate school and teaching. Others work as independent artists, with work in galleries and museums nationally and internationally. An increasing number receive commissions for architectural and other large-scale works, while others become art consultants and conservators.

Industrial Design. Industrial design students benefit from the real-world philosophy of CIA's department, which emphasizes innovation to fit a market. This philosophy is demonstrated by a faculty of working designers who are part-time educators. As independent designers and business owners, they represent many aspects of industrial design as it is currently practiced — product design, graphics for consumer and commercial markets. The program begins with a firm grounding in design fundamentals, with an integrated understanding of aesthetics, selection and use of materials, and engineering needs. Students learn that a good product is a functional sculpture, but it must perform its function optimally. This analytical approach, along with a technical vocabulary and the skills to articulate an idea in two- and three-dimensional forms, enables our students to adapt to rapidly changing technologies and markets. Students design a variety of products: transportation, consumer electronics, toys, dinnerware, furniture. They learn to generate, test, and support their ideas via model-making and presentation skills. They also learn how the computer as a design tool is changing the process of product development.

iNdusTria l

design

CIA's industrial design department stands out in the versatility of its graduates, who learn to integrate product, transportation, and graphic design; for example, auto design, with its strong tradition here, is taught from the realistic perspective that a car is a product on a large scale. Our graduates work as designers for automotive companies worldwide, and for manufacturers of consumer and industrial goods. Many have established their own consulting design firms.

Designers are increasingly challenged to make better products at less cost. The only way to do that is to understand manufacturing techniques and innovations. Such analysis is time-consuming, but realistic. Hugh Greenlee

ART DIRECTOR/DESIGNER: Todd Houser

STUDIO: Pinkhaus, Miami, FL

CLIENT: Howard Shusterman

PHOTOGRAPHERS: Howard Shusterman, Todd Houser

TYPEFACES USED: Ribbon, Matrix (copy); Mason (headline)

TYPE DESIGNERS: Zuzana Licko (Matrix), Jonathan Barnbrook (Mason)

SOFTWARE: Adobe Illustrator, Adobe Photoshop

COLORS: Four-over-four, process, plus extra run of black

PRINT RUN: 6,000

CONCEPT: This invitation "screamed Bar Mitzvah!" says designer Todd Houser. "I got some personal touches in the poster by adding the little illustrations that depict aspects of turning into a man that related directly to Jared." The poster-like invitation was folded into quarters to be self-mailed.

INSPIRATION: "Trying to capture the energy and excitement of a boy turning into a man. Also, I needed to create a look that was pleasing to a thirteen-year-old yet still kept his parents happy."

SPECIAL PRODUCTION TECHNIQUES: "A ton of Photoshop work! And the second black really adds depth to the solid blacks on this uncoated sheet," says Houser. A touch of fluorescent yellow was also added to the 100 percent process yellow.

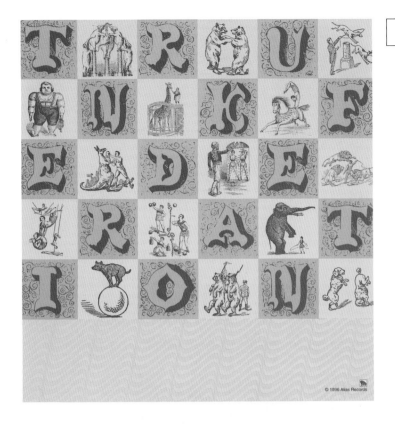

TRUNK FEDERATION TOUR POSTER

ART DIRECTOR/DESIGNER: Cole Gerst

STUDIO: Alias Records/Burbank, CA

CLIENT/PRODUCT: Alias Records/music

TYPEFACES USED: Found woodblock typeface

SOFTWARE: Adobe Photoshop, QuarkXPress

COLORS: Two, match

PRINT RUN: 3,000

COST PER UNIT: $1.25

CONCEPT: This tour poster for the band Trunk Federation "is very easy to see in dark clubs—where it gets put most," says designer Cole Gerst.

INSPIRATION: "After talking with the lead singer for the band, I realized how much he liked the circus," says Gerst. "I wanted to make something eye-catching but not so obvious. This use of color and layout gets your attention and demands you to look at it to understand it."

SPECIAL COST-CUTTING TECHNIQUES: Since the color and layout were attention-getting on their own, Gerst reduced the size of the poster to 15" × 14".

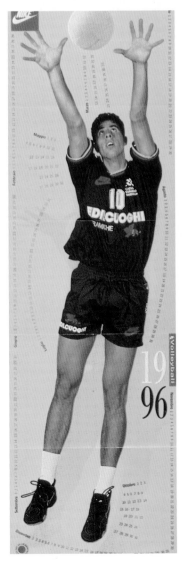

NIKE VOLLEYBALL CALENDAR

ART DIRECTOR: Emanuela Nanetti

STUDIO: Matite Giovanotte, Forli, Italy

CLIENT/PRODUCT: Nike Italy/sports and fitness apparel

PHOTOGRAPHER: Werther Scudellari

TYPEFACES USED: Scala, Meta

TYPE DESIGNERS: Martin Majoor (Scala), Erik Spiekermann (Meta)

SOFTWARE: Macromedia FreeHand, Adobe Photoshop

COLORS: Four, process

COST PER UNIT: $1

CONCEPT: This Nike volleyball calendar, which was included in the January issue of a volleyball magazine, utilizes a close-to-full-size image of the national volleyball team captain, and surrounds this image with calendar numbers whose layout mirror—and emphasize—his movement. All the red numbers on the calendar are Sundays—the day of the week Italian volleyball teams usually play.

DESIGNER: Dom Raban

STUDIO: Eg.G, Sheffield, England

CLIENT: Forced Entertainment Theatre Company

PHOTOGRAPHER: Hugo Glendinning

TYPEFACES USED: Univers, Playbill (modified)

SOFTWARE: Adobe Illustrator, Adobe Photoshop, Infini-D

COLORS: Two, match

PRINT RUN: 5,000

COST PER UNIT: £0.13

CONCEPT: Inspiration for this piece was taken from elements within the narrative of the play, according to Dom Raban: "The clocks counting down to midnight were modelled in Infini-D, while the 'show' type is reminiscent of decaying illuminated signs at fairgrounds. The fractured body copy reflects the anarchic performance style of the company."

SPECIAL PRODUCTION TECHNIQUES: "Three-dimensional layering of multiple duotones with clipping paths to exploit to the fullest potential the limitations of working with two colors."

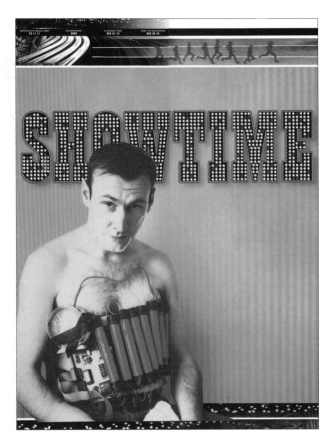

ART DIRECTORS/DESIGNERS: Nancy Mazzei, Brian Kelly

STUDIO: Smokebomb, Brooklyn, NY

CLIENT: *KGB Magazine*

PHOTOGRAPHER: Lukas Barr

TYPEFACES USED: Backspacer, Champion, Fiedler Gothic, Suburban, Teenager

TYPE DESIGNERS: Smokebomb (Backspacer, Teenager), Rudy VanderLans (Suburban)

SOFTWARE: QuarkXPress, Adobe Photoshop

COLORS: Four, process

PRINT RUN: 25,000

CONCEPT: "My original concept for this cover was to create the film and to manipulate the registration on press so that the crop marks and other technical information would become part of the design," says designer Brian Kelly. "The printer, however, was not so willing to do this, afraid that it would 'reflect badly on the quality control aspects of his plant.'" Nevertheless, Kelly feels the final design still "incorporates elements that most people are not familiar with from the printing process and involves the reader in the process of magazine design."

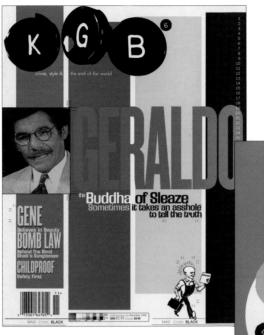

ART DIRECTOR: John Ball

DESIGNERS: John Ball, Deborah Hom

STUDIO: Mires Design, San Diego, CA

CLIENT/SERVICE: California Center for the Arts/ museum

TYPEFACE USED: Officina

SOFTWARE: QuarkXPress

COLORS: Four, process, over two, match

PRINT RUN: 2,000

COST PER UNIT: $10

CONCEPT: "Everything we did supported, but did not detract from, the artwork in the exhibition," says John Ball of this exhibition catalog for the California Center for the Arts.

INSPIRATION: "The big, bright, contemporary sculpture in the exhibition."

SPECIAL PRODUCTION TECHNIQUES: Four-color process pages were interleaved with two-color duotone pages and one-color pages on yellow stock.

ART DIRECTORS/DESIGNERS: Sonia Greteman, James
Strange

STUDIO: Greteman Group, Wichita, KS

CLIENT: Wichita State University Alumni Association

PHOTOGRAPHER: Ron Berg

TYPEFACES USED: Bureau Agency, Garamond, Avant
Garde, Insignia

COLORS: Four, match

PRINT RUN: 1,000

COST PER UNIT: $4

CONCEPT: This call for entries for a fine art contest
"worked for the client because it captured the
artists' attention and prompted them to send in
entries," according to designer Sonia Greteman.
"Graphically simple imagery combined with
arresting typography to generate interest, while
the center die-cut picture frame challenged the
artists to fill the void. The piece dared them to
create."

INSPIRATION: "The inspiration for the design of this
piece was the photography. The images strive to
capture the creative process—from idea germina-
tion and gestation to full development."

SPECIAL COST-CUTTING TECHNIQUES: "The use of a
simple, square die-cut in the center and doing all
scans in house."

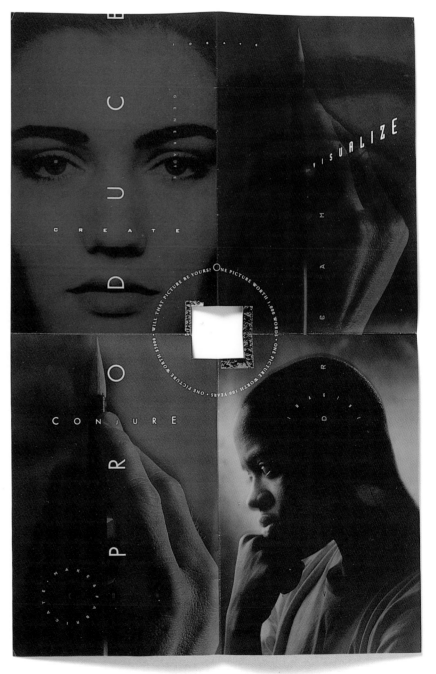

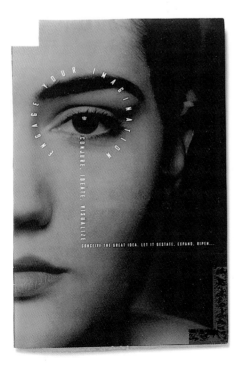

AT&T JENS BROCHURE

ART DIRECTOR: Kenzo Izutani

DESIGNERS: Kenzo Izutani, Aki Hirai

STUDIO: Kenzo Izutani Office Corporation, Tokyo, Japan

CLIENT/PRODUCT: AT&T Jens Corporation/ communications

PHOTOGRAPHER: Yasuyuki Amazutsumi

COLORS: Four, process, plus two, match

CONCEPT: Kenzo Izutani used soft, gentle colors and photographs of leaves and flowers to warm up the image of his international corporate client, AT&T.

ART DIRECTOR/DESIGNER: Mark R. Robinson

STUDIO: Teenbeat Graphica, Arlington, VA

CLIENT: 4AD Records

ILLUSTRATOR: Hideaki Kodama

TYPEFACES USED: Gill Light, Futura Book

SOFTWARE: QuarkXPress

COLORS: Four, process

PRINT RUN: 25,000

COST PER UNIT: $1.25 (including CD)

CONCEPT: The cover image—a photorealistic airbrush illustration—is the centerpiece for this CD design. "The band was fond of slick late seventies/early eighties new wave record sleeves and the illustration fit into that—that lip gloss look," says designer Mark R. Robinson.

INSPIRATION: "The original design was inspired by an old 7" single by New Musik entitled 'World of Water,' which used the style of a square with a white frame. Once we found Hideaki Kodama's illustration, everything came together. Peter Saville's work at Factory Records in the 1980s was also inspirational."

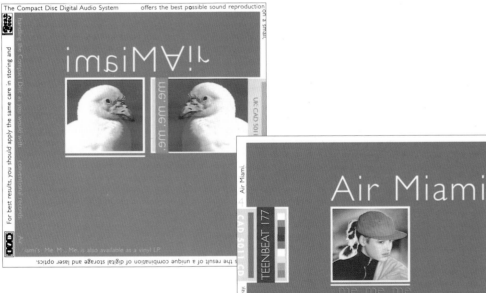

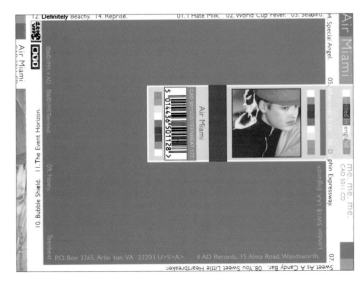

ART DIRECTOR: Mark Sackett

DESIGNERS: Mark Sackett, Wayne Sakamoto, James Sakamoto, Eric Siemens

STUDIO: Sackett Design Associates, San Francisco, CA

CLIENT/SERVICE: The Hard Way/a new licensing concept for applications to apparel, snowboards and various retail products

ILLUSTRATORS: Wayne Sakamoto, James Sakamoto, Eric Siemens

PHOTOGRAPHER: Stock

TYPEFACES USED: Courier, Matrix (brochure copy); Copperplate, Futura, Helvetica, Courier, Matrix, Machine, City, OCR-B, ITC Kable (graphics)

TYPE DESIGNER: Zuzana Licko (Matrix)

SOFTWARE: Adobe Illustrator, Adobe Photoshop, QuarkXPress

COLORS: Four, process

PRINT RUN: 200

COST PER UNIT: $7

CONCEPT: "Our client's need for graphics geared to youth-oriented markets" drove this brochure design for The Hard Way, according to Mark Sackett.

SPECIAL PRODUCTION TECHNIQUES: Various Photoshop and Illustrator filters were used to create the brochure's graphics.

SPECIAL COST-CUTTING TECHNIQUES: "This brochure was printed using the digital printing process," says Sackett. "Since most of the graphics were in four-color process and the run was very short, the process was very economical compared to the traditional printing process."

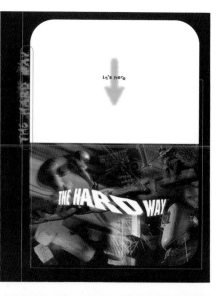

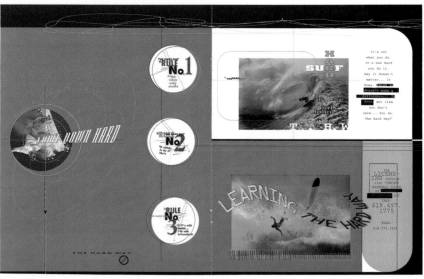

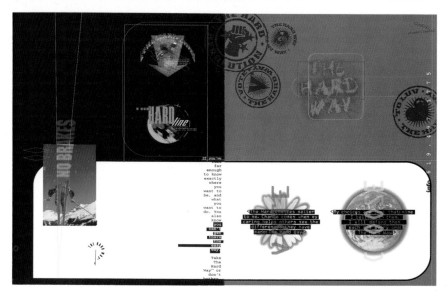

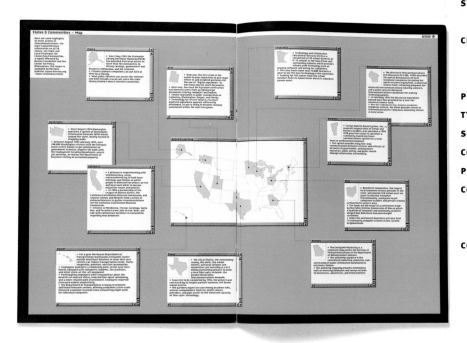

ART DIRECTORS: Peter Grundy, Tilly Northedge

DESIGNERS: Peter Grundy, Kim Bieler

STUDIO: Grundy & Northedge, London, England, in association with CDI, Washington, DC

CLIENT/SERVICE: The Benton Foundation/nonprofit organization working to realize the social benefits of communication

PHOTOGRAPHER: Various

TYPEFACES USED: Various

SOFTWARE: QuarkXPress, Adobe Illustrator

COLORS: Six, match

PRINT RUN: 20,000

COST PER UNIT: $3, including mailing costs

CONCEPT: The concept behind this newsletter for a nonprofit organization promoting better communication was to create "a magazine that looked and worked like a Web site," says Peter Grundy. By doing this, Grundy & Northedge hoped to create "a new metaphor—moving from the print metaphor to the Web/electronic metaphor."

PAI ON QIN QI "THE TRIAL"

ART DIRECTOR: Freeman Lau Siu Hong

DESIGNERS: Freeman Lau Siu Hong, Veronica Cheung Lai Sheung

STUDIO: Kan & Lau Design Consultants, Hong Kong

CLIENT/PRODUCT: Zuni Icosahedron/drama and dance performance company

PHOTOGRAPHER: C.K. Wong

COLORS: Two, match

CONCEPT: The unusual shape of this brochure—a program for a performance of a play based on Kafka's "The Trial"—is a reference to the fact that in this theater, the stage is placed in the middle of the audience.

他望着他問他，告訴我，誰是最誠實的，誰是最寬容的，誰是最通情的。他問他，告訴我，誰是最有理想的，誰是最有宗旨的，誰是最有視野的。

他望着他，發現自己再不在他眼裡，他心中有鬼，他突然失掉所有信心，他失去了影子，他不能見光。在他的眼裡，他已經再不存在。他成了一縷幽光，一些過去了的事。

只有在他面前，他原形畢露，難能掩飾。因此他將他藏在家裡，不讓他見光，見人，也不讓別人見到他倆在一起。但是，他又捨不得他，因為只有他，才能讓他想起自己，真正的自己。

他義無反顧地進入他裡面，就像某一樓道治成咒語，只有他能解開。他進入他的裡面時，他進入了另一個世界，一切失去重心，如煙如霧，浮在半空中。他將他抱轉身，後面竟然是一具裸體。他將他翻過來，再走進他裡面，就像某一樓道治成咒語，興誓不能自已，他覺得自己就脫而出。他超脫樂世界。他喜極而泣，不能自己。

他專歡他，先是因為些許虛榮，跟着是因為他讓他覺得自己重要。到了一個地步，他解釋他能跟他學到服侍他的東西，讓他開展了他的視野，然後建立了他的自信。他不斷為找尋存在價值的藉口，為找我相互關係訂立的經營。他加知，他們之間，是有一道界限，沒有了界限，彼方就蕩清雲散，有了界限，就牢牢抓緊。他對着他笑，他就哭，他對着他哭，他就笑；他後退，他也後退；他前進，他前進着；他前進，虛到他倆珠在一起，隔着一道冰凍的界限，臉貼着臉，眼光如絲如縷，碧藍着碧限，一陣纏綿的界限，令他驟然生集，着實失落了一陣。他們相互予心貼着手心，全國抹掉那一層透柳的界限，才發現是沒有可能的，他們只能此為止。再過不了這個關口，越不了這個阻滯。他的眼睛只了關係，救了關係，沒人對沒人，相互相欠相恐借。沒有可能的，根本沒有可能的，他玫玫退後，退到沒有光的地方。

他不能面對自己，他卻認為他該負起責任，是他令他無地自容，抬起頭卻眼光對着眼光，哭了，怎惡地失心藏地咒罵一拳打他；在無數的碎片中，他看到無數的無數眼光的他。

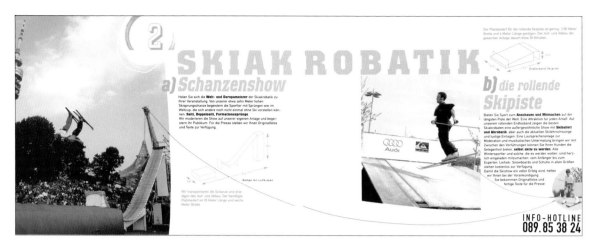

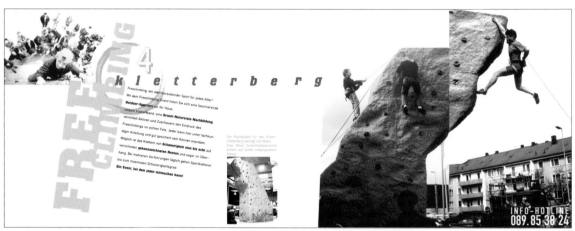

ACTION-TEAM BROCHURE

DESIGNER: Olaf Becker, München, Germany

CLIENT/PRODUCT: Action-Team GMBH/snowboard and freestyle-ski shows

PHOTOGRAPHER: Various

TYPEFACES USED: Din Mittelschrift (text and cover), Colossalis Bold (headlines and logo), City (numbers)

COLORS: Two-over-one and four, process

CONCEPT: The client for this brochure, an organizer of snowboard and ski shows, "had nearly nothing for promotion," says Olaf Becker. "We had to create something completely new and he let me work completely free. Inspiration was the photos, text and a lot of conversation with him. We wanted to be serious and crazy at the same time, so we used neon orange on the cover and a very calm layout in the inner part."

SPECIAL COST-CUTTING TECHNIQUES: For the cover, Becker scanned a paper he couldn't afford and printed the texture on a cheaper white paper stock. A cutout was also used, so that a four-color photograph could show through to the two-color cover.

ART DIRECTOR/DESIGNER: Joshua Berger

STUDIO: Plazm Media, Portland, OR

CLIENT/PRODUCT: Plazm Media/magazine, digital type foundry, design group

TYPEFACES USED: Roscent, Roscent Italic, Roscent Bold

TYPE DESIGNER: Angus R. Shamal (all fonts)

SOFTWARE: Adobe Photoshop, QuarkXPress

COLORS: One, black

PRINT RUN: 8,000

CONCEPT: "In the digital age, a copyright infringer can reproduce a perfect match of an original creation instantly and infinitely without any loss of quality," says designer Josh Berger. "Negativland creates music from found bits of sound, including parts of other songs, appropriating in the same fashion as visual collage artists before them. The layout uses the band's anti-copyright logo as a metaphor for the context of our discussion and as a euphemism for the speed of the information age."

SPECIAL PRODUCTION TECHNIQUES: Photocopying, scanning and bitmapping of text.

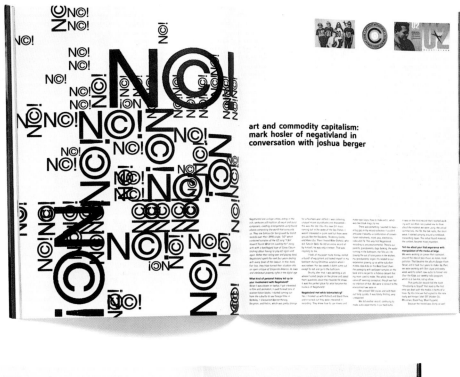

art and commodity capitalism: mark hosler of negativland in conversation with joshua berger

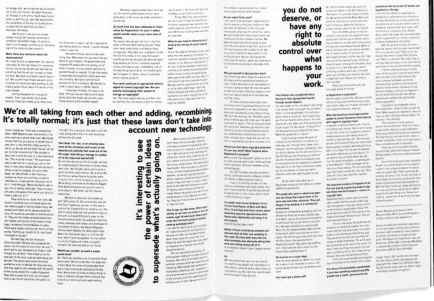

COPYRight notices

index of design firms

INDEX of pieces